Disorder in Progress

Published by Die-Gestalten Verlag

Curated & Edited by Nando Costa

Cover Design by Nando Costa

Three-Dimensional Artwork by Kevin Cimini

Where to Start

This publication is dedicated to all of those who wish to change their surroundings, improve their lives and the lives of others but are stranded in artistic endeavours, unsure of how their tools and talent could make a difference.

This is a collection of original artwork created by such people. By portraying social issues that intrigued or disturbed them, some of these artists hoped to not only exorcise their frustrations, but also change perceptions and perhaps spark a creative movement.

Born & Raised or Not

We have invited artists that have originally been born in Brazil and some from foreign countries whose experiences in the country were significant enough for them to deeply understand its culture.

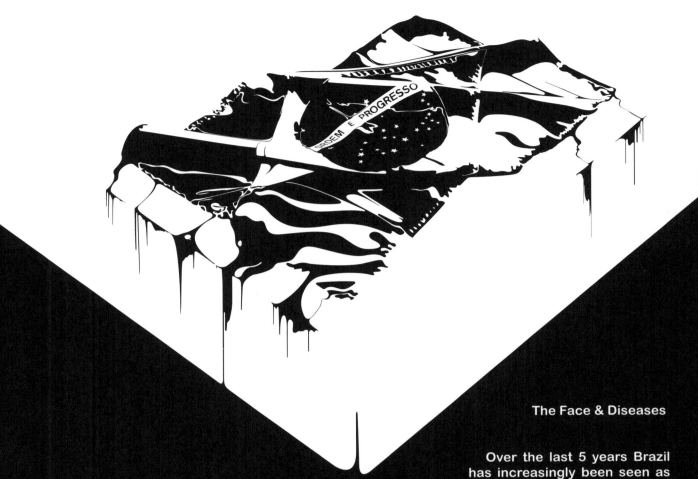

The Face & Diseases

Over the last 5 years Brazil has increasingly been seen as an attractive destination for foreigners and a popular subject for news organizations across the globe. But it not always for the reasons natives wished for.

The soccer nation reputation, the welcoming natural exuberance and the iconic music are among some of the culture characteristics that make locals proud. But the Brazilian culture has produced other not so desired stereotypes.

The cover of this book attempts to graphically and subjectively showcase the colourful and glossy outer skin of the nation, while the interior pages showcase artistic views of some of the harsher realities in the country's history and present.

"This is a government that has not been putting the dirt under the carpet."

Quote by Luiz Inácio Lula da Silva, Brazilian President as of the printing date of this book.

Collected from Wikipedia.org (Wikiquote)

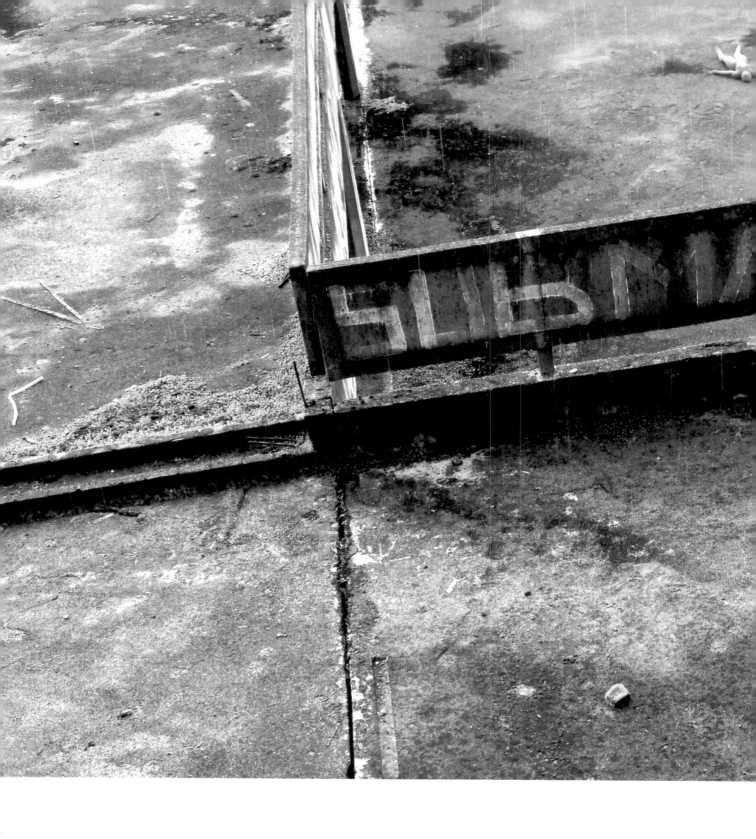

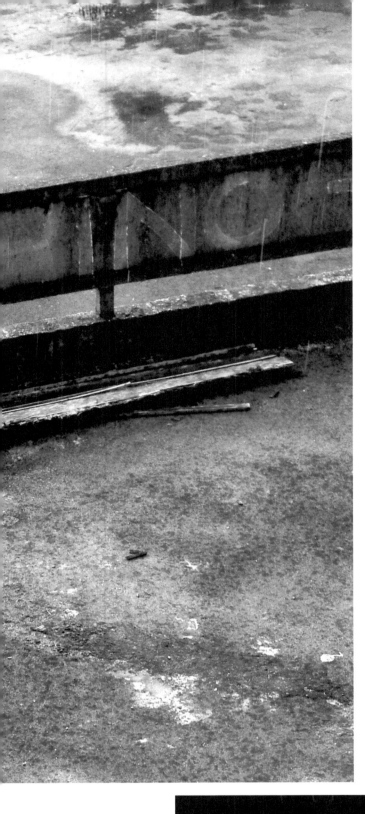
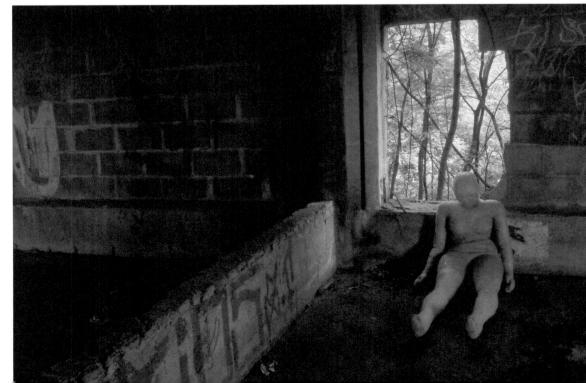

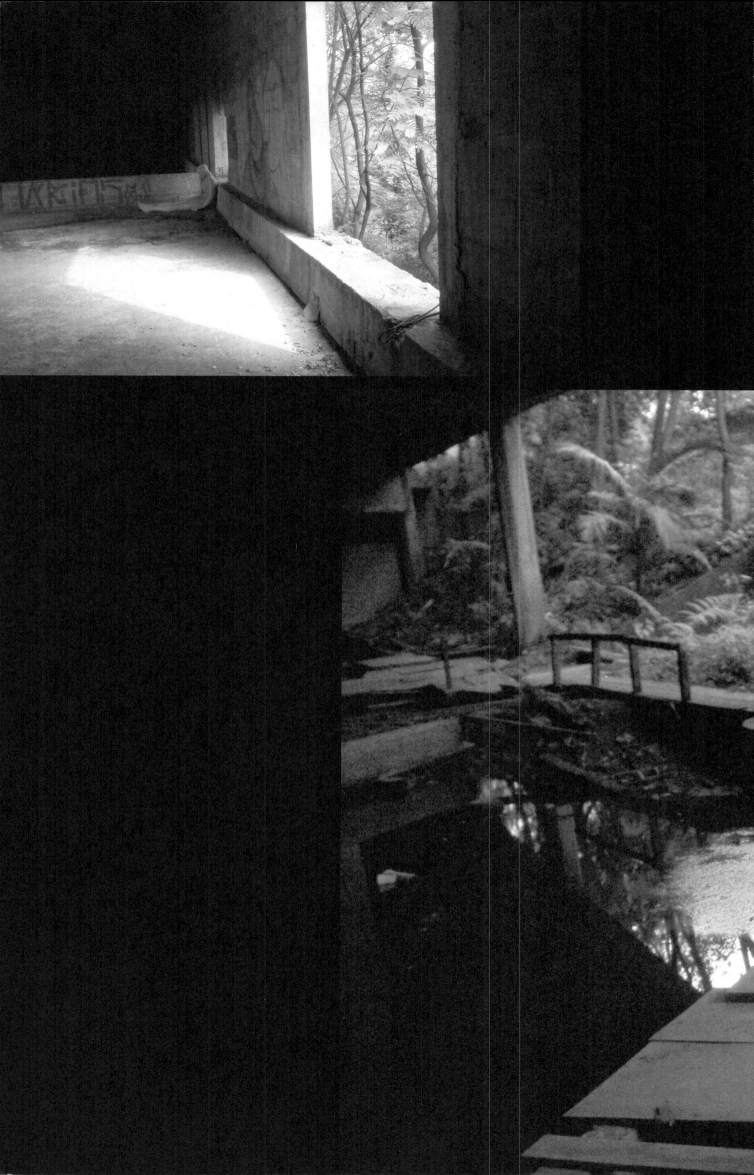

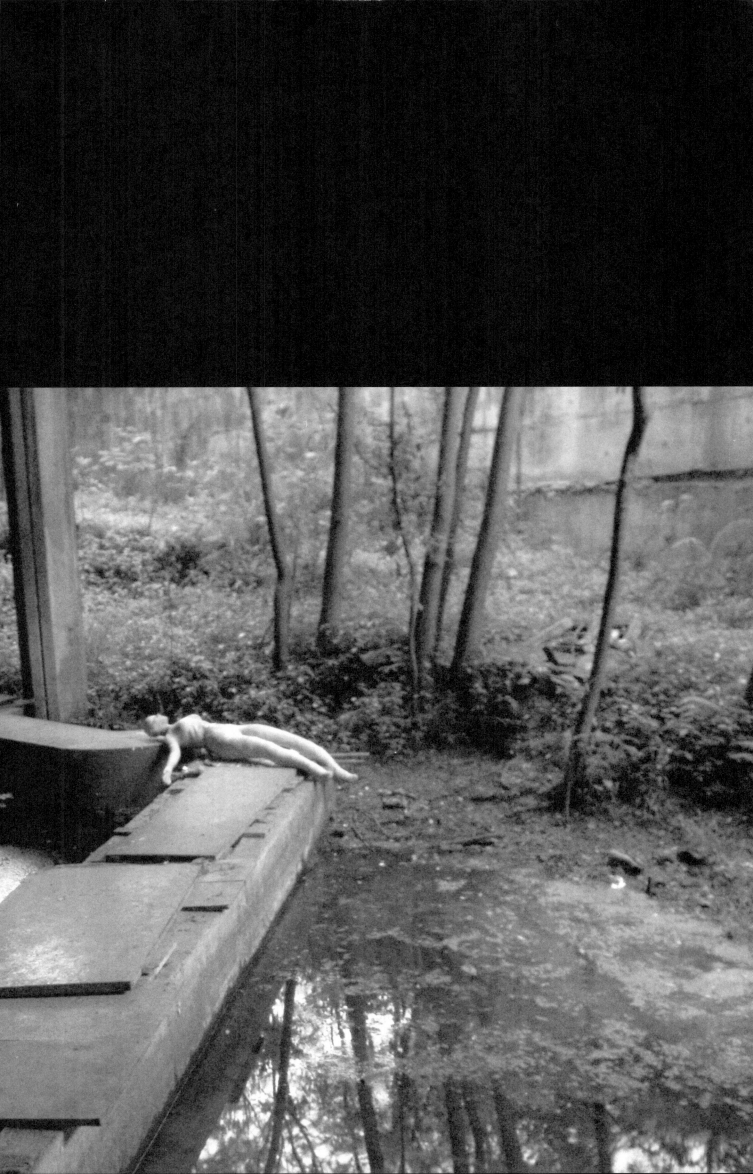

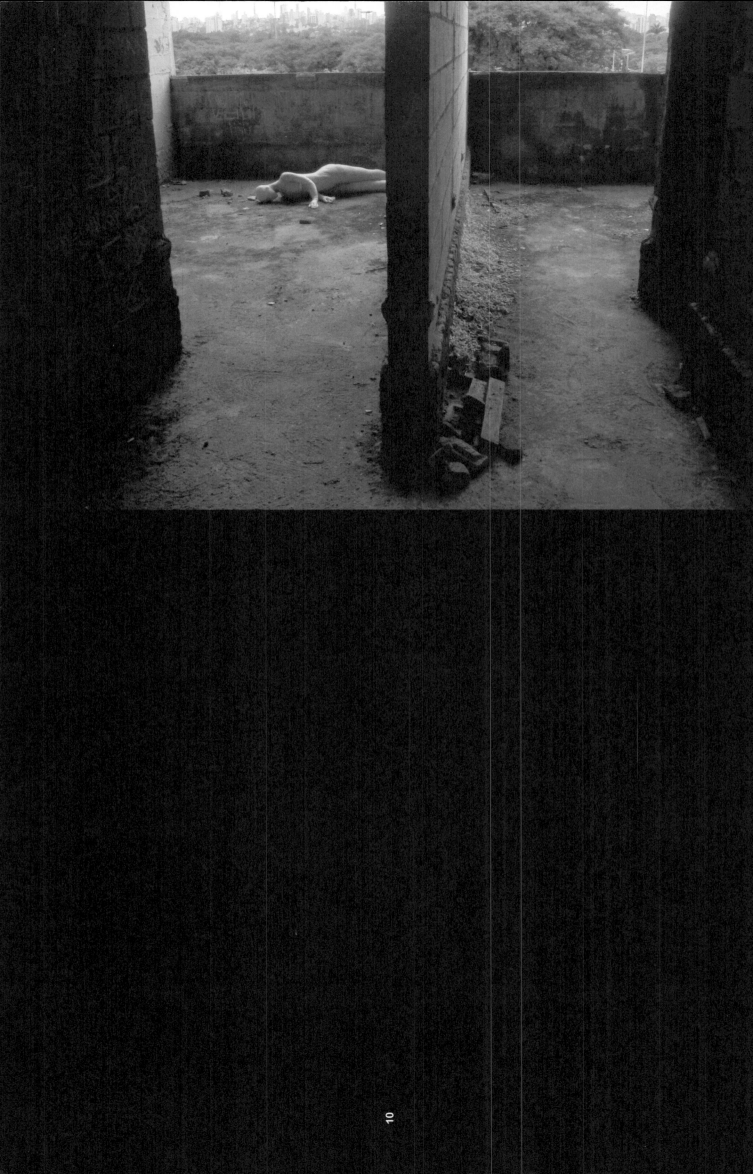

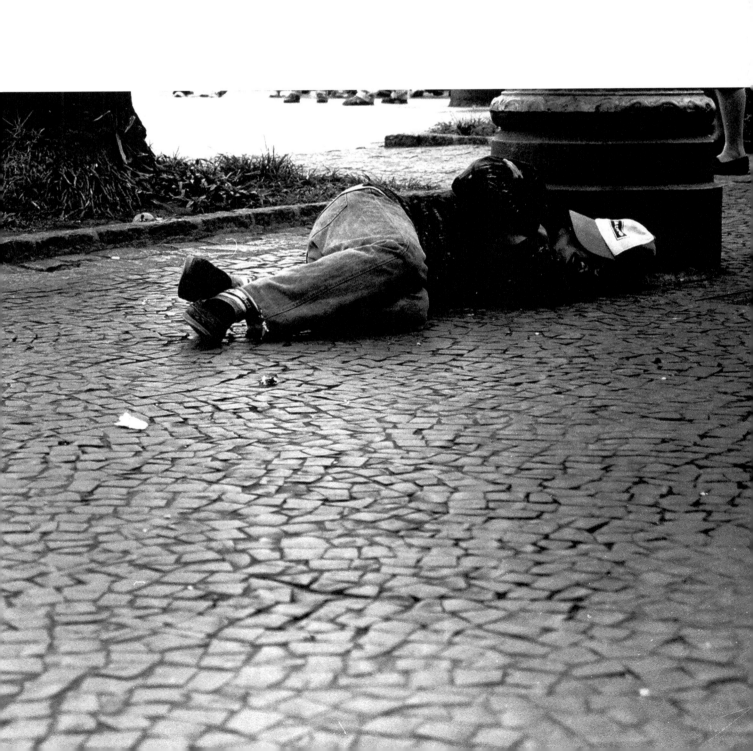

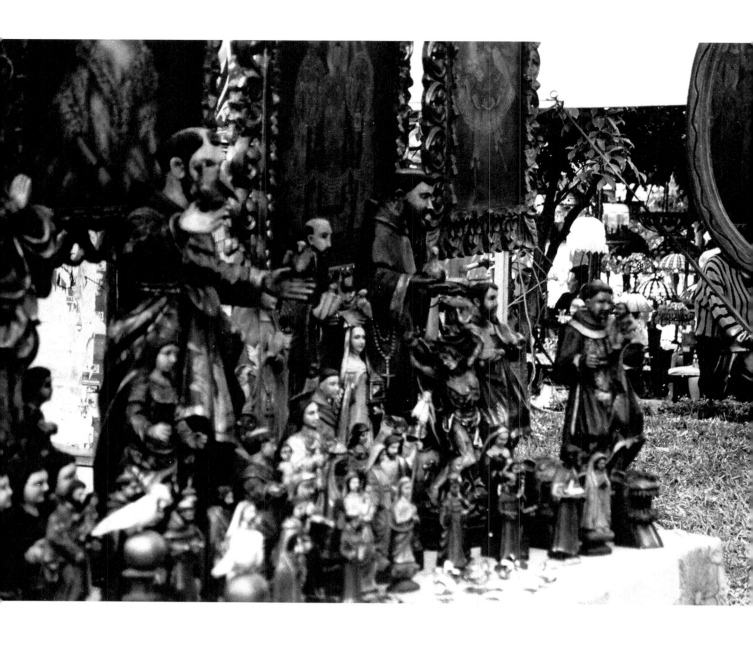

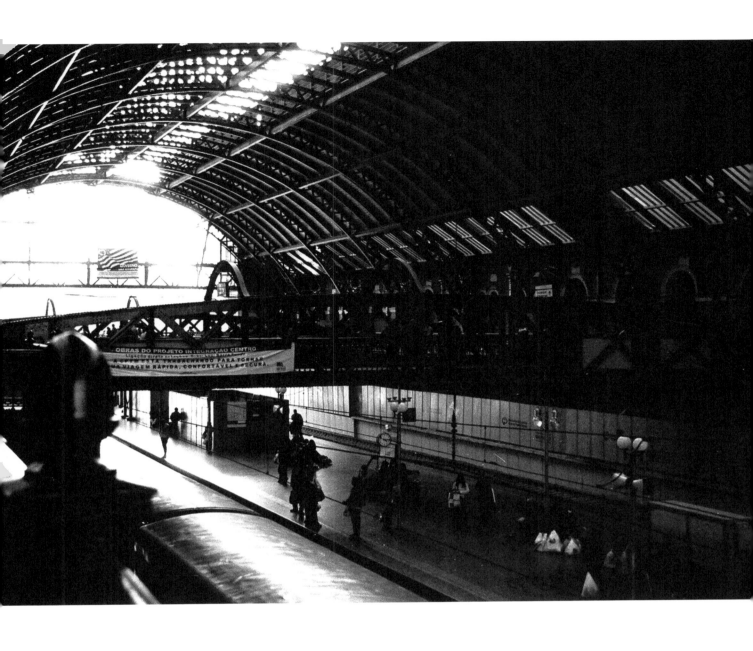

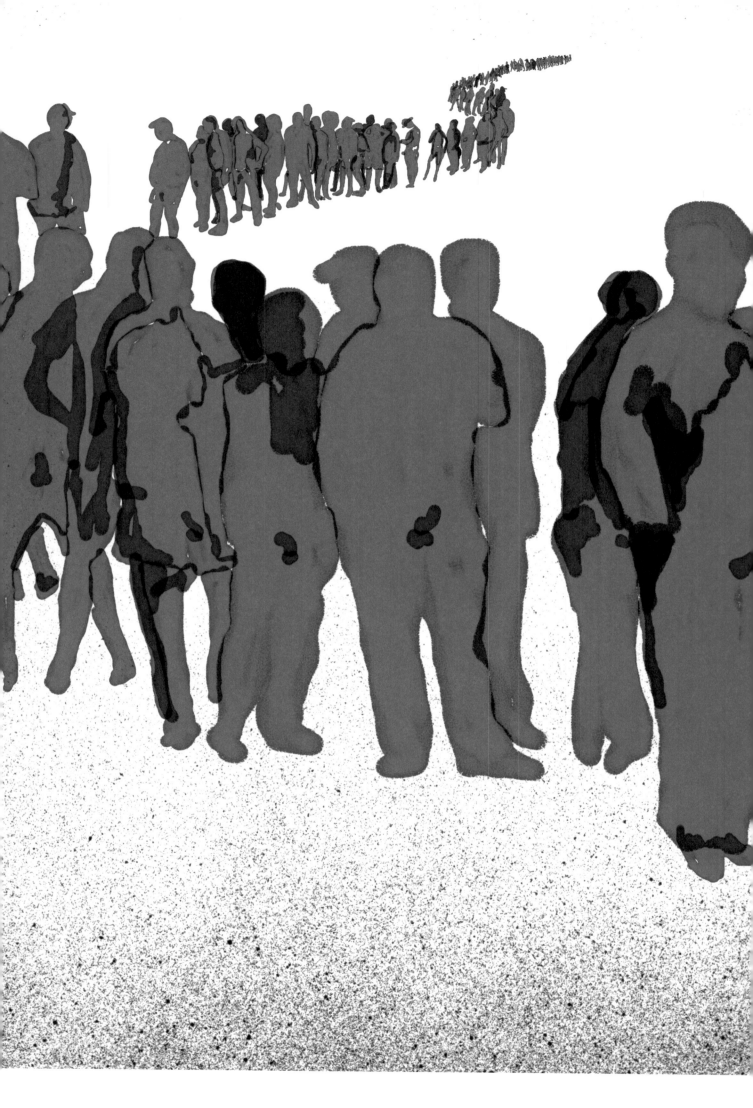

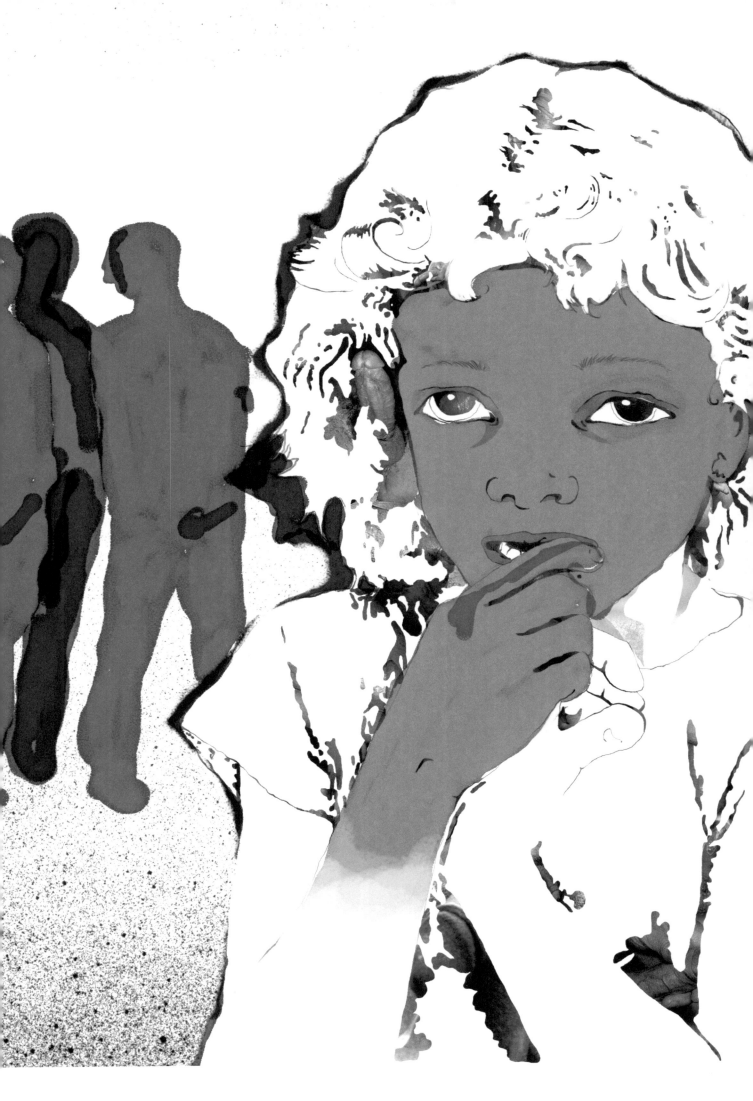

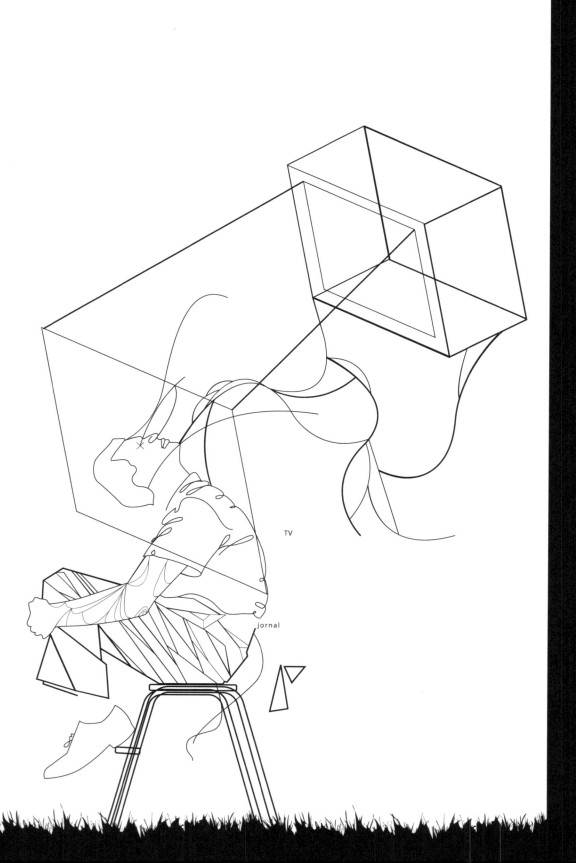

TV

jornal

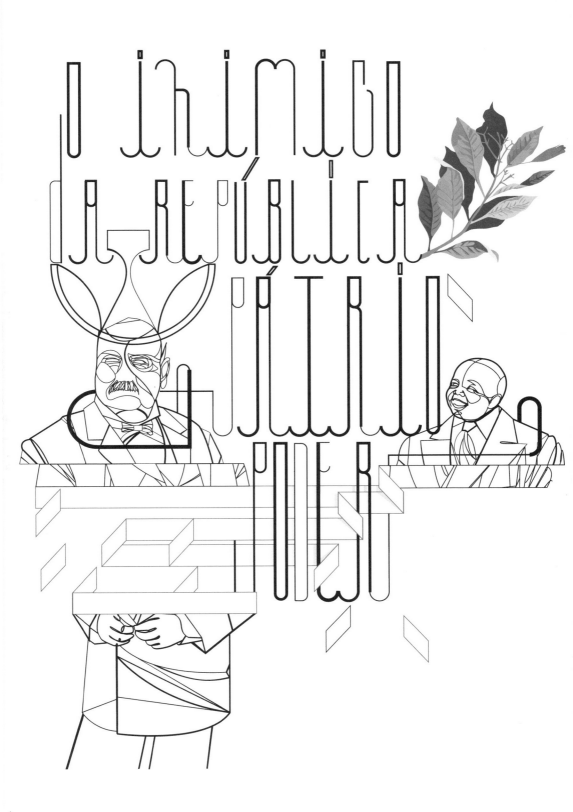

O INIMIGO DA REPÚBLICA É A PÁTRIA

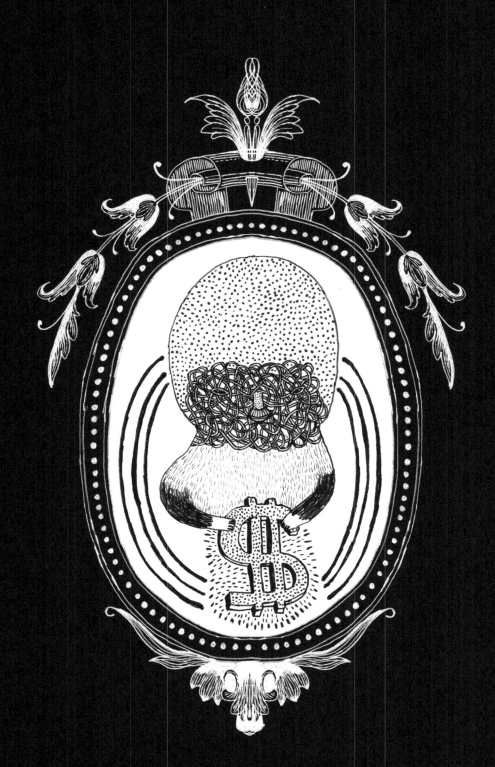

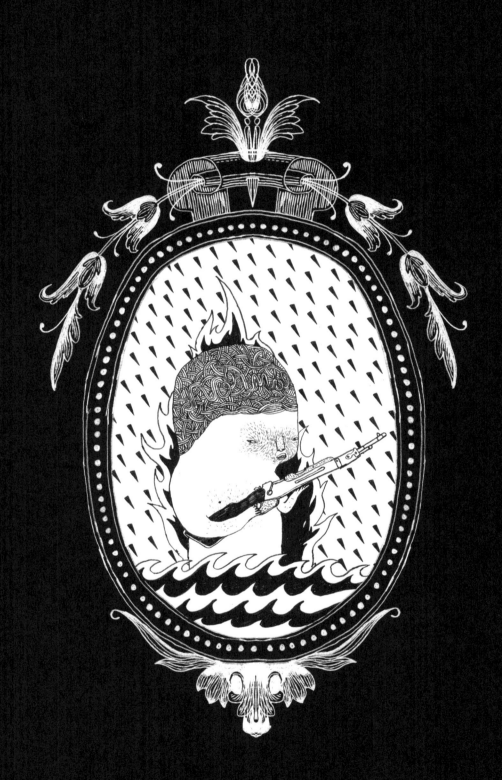

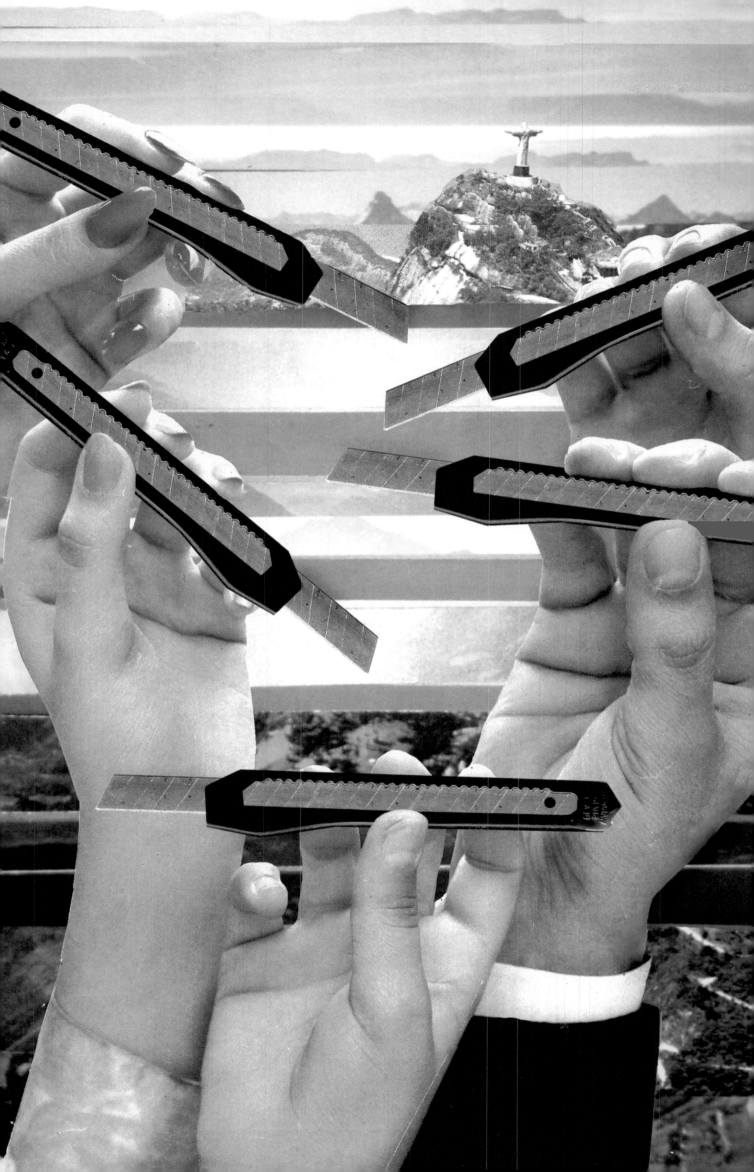

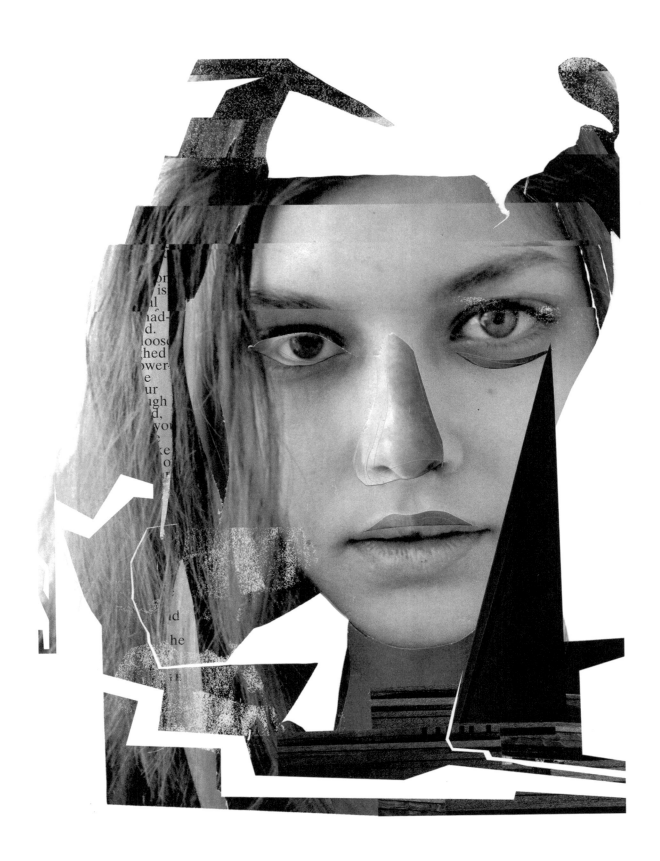

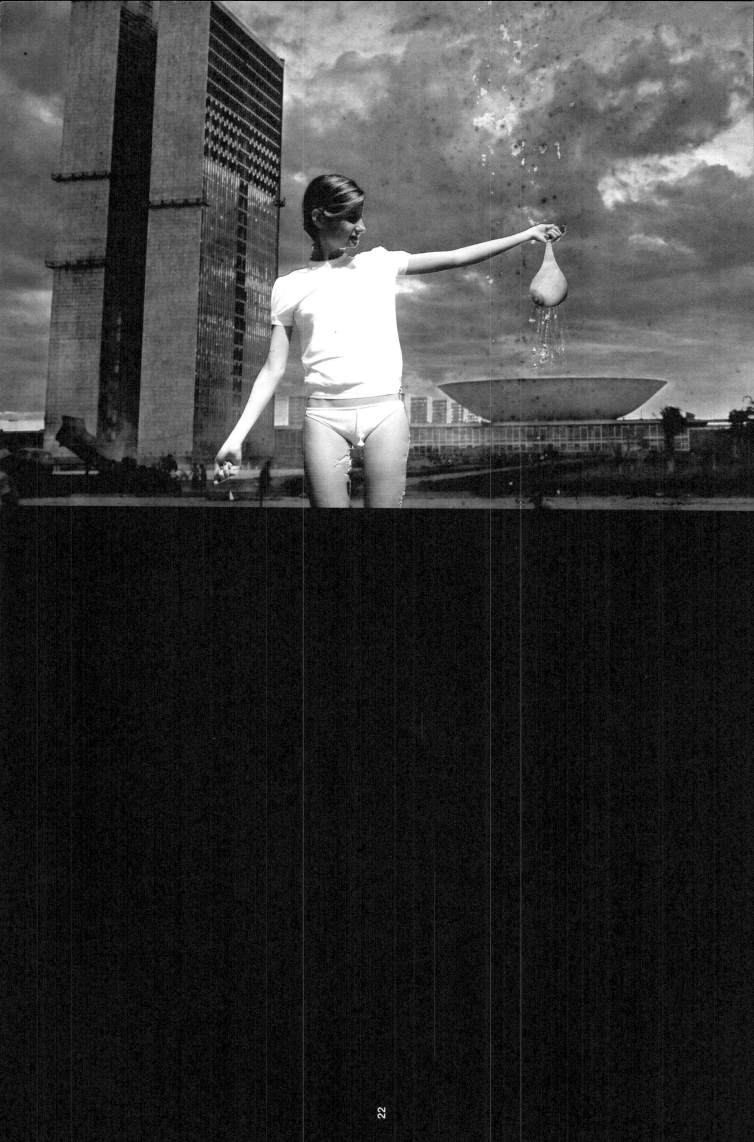

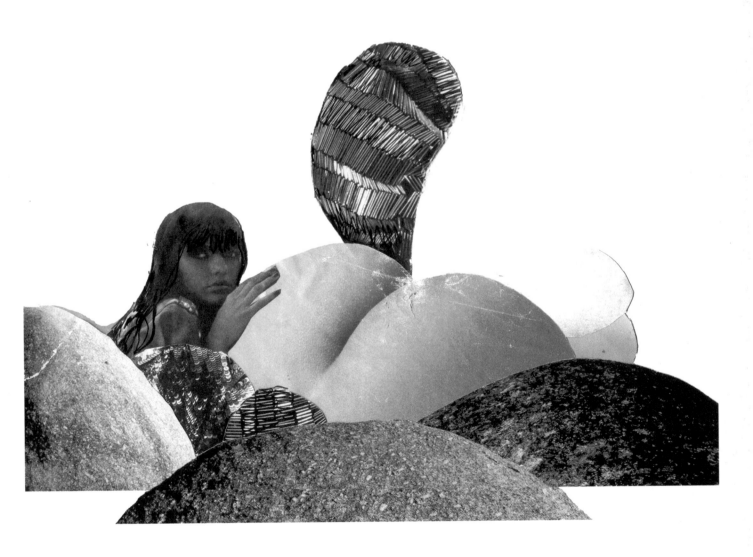

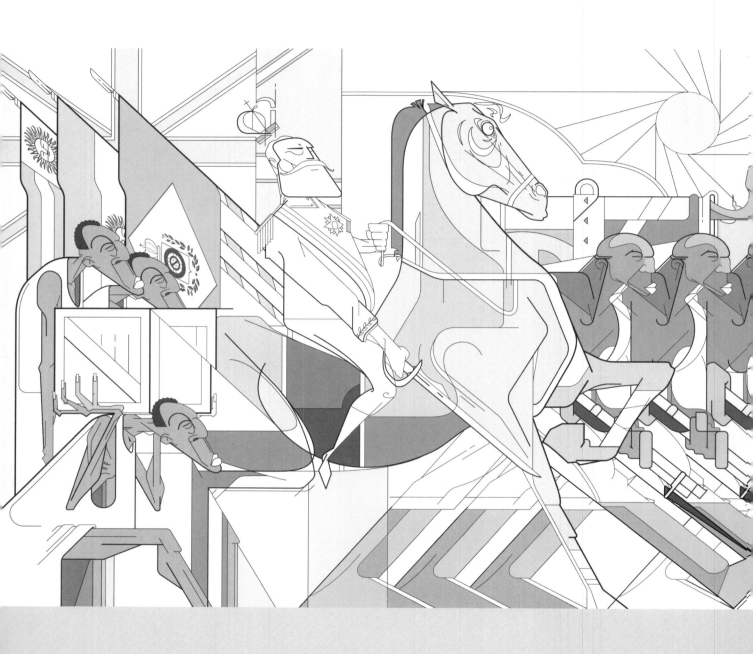

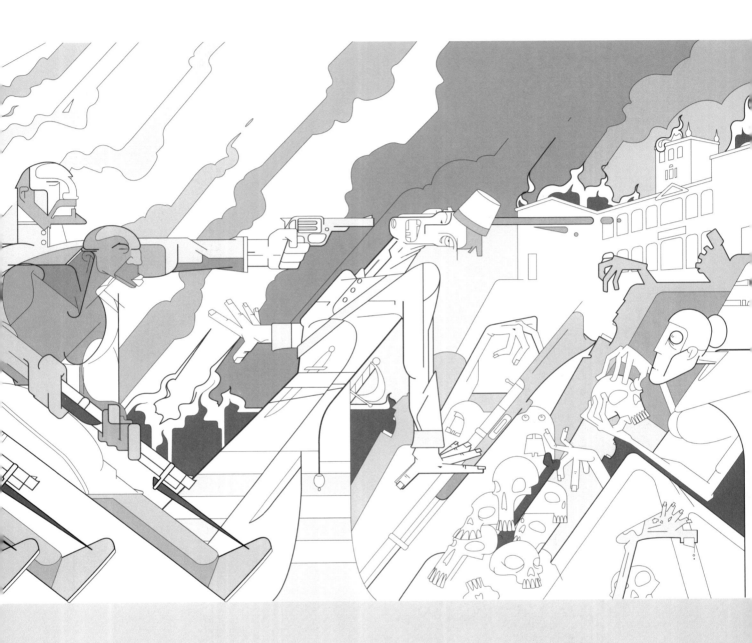

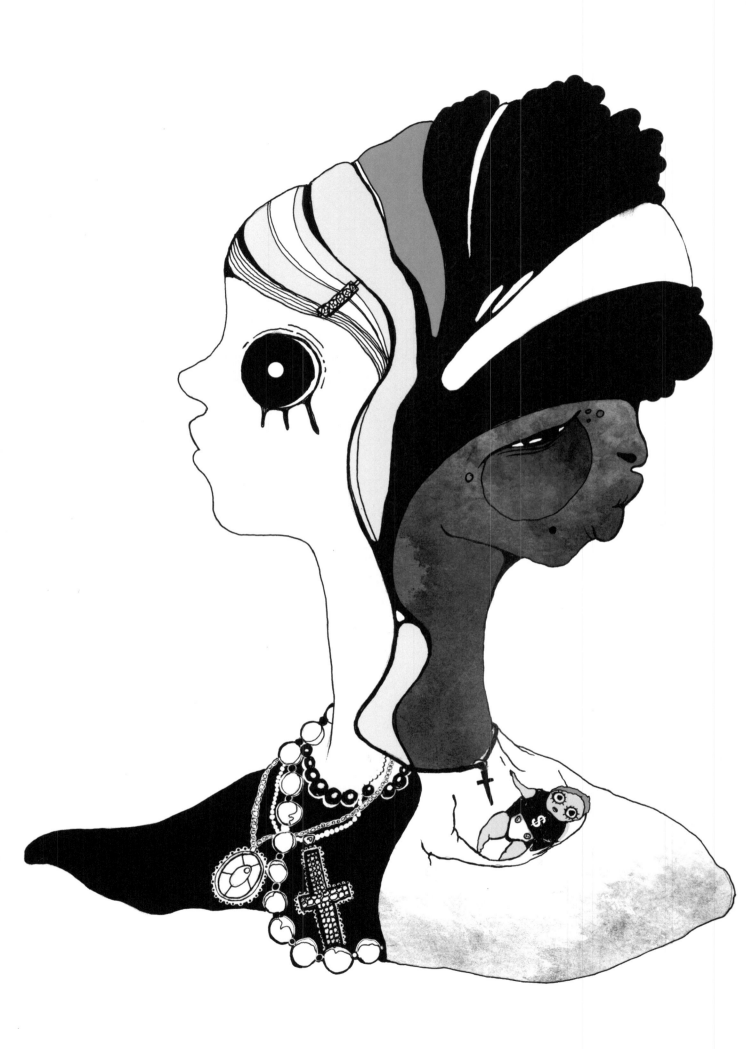

abcdefghIJL

abcdefghIJL

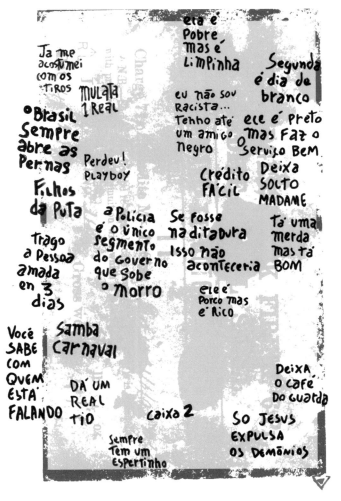

Ja me acostumei com os tiros

Mulata 1 Real

o Brasil Sempre abre as Pernas

Filhos da Puta

Perdeu! Playboy

a Polícia é o único segmento do Governo que Sobe o Morro

trago a Pessoa amada en 3 dias

ela é pobre mas é limpinha

eu não sou Racista... Tenho até um amigo negro

Crédito FÁCIL

Se fosse na ditadura

Isso não aconteceria

ele é Porco mas é Rico

Segunda é dia de branco

ele é preto mas faz o serviço Bem

Deixa Solto MADAME

Tá uma merda mas tá BOM

Você SABE com Quem Esta FALANDO

Samba Carnaval

Dá um REAL tio

caixa 2

Sempre Tem um espertinho

Deixa o Café Do Guarda

So Jesus EXPULSA os Demônios

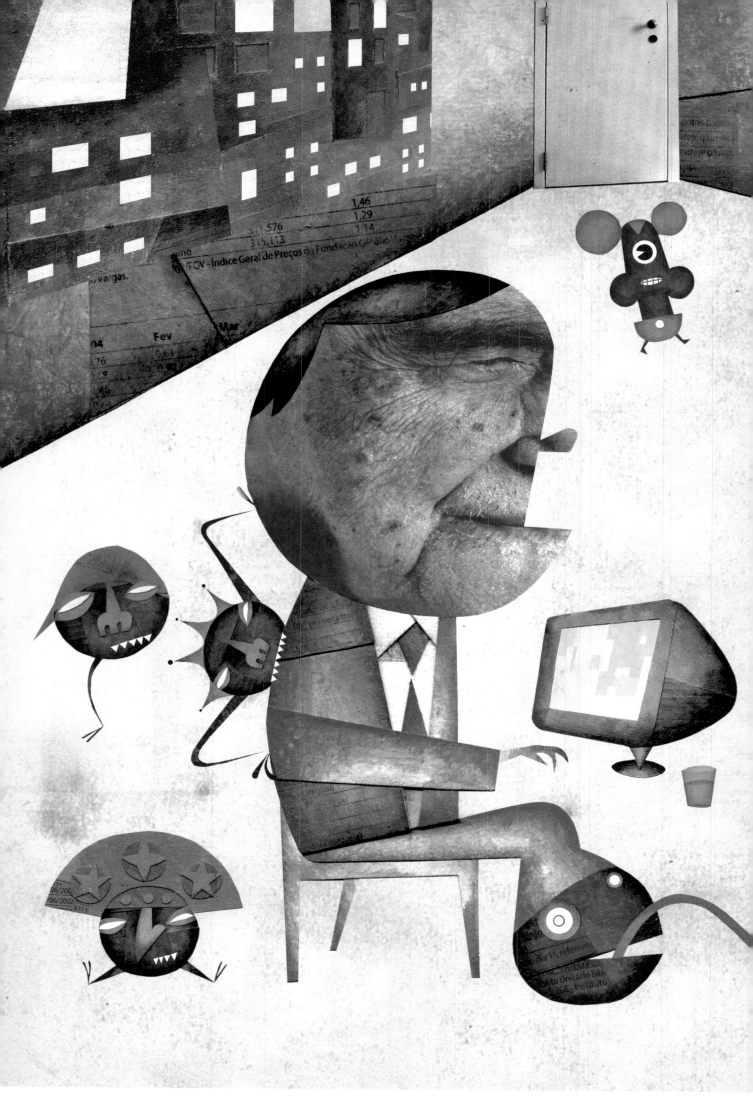

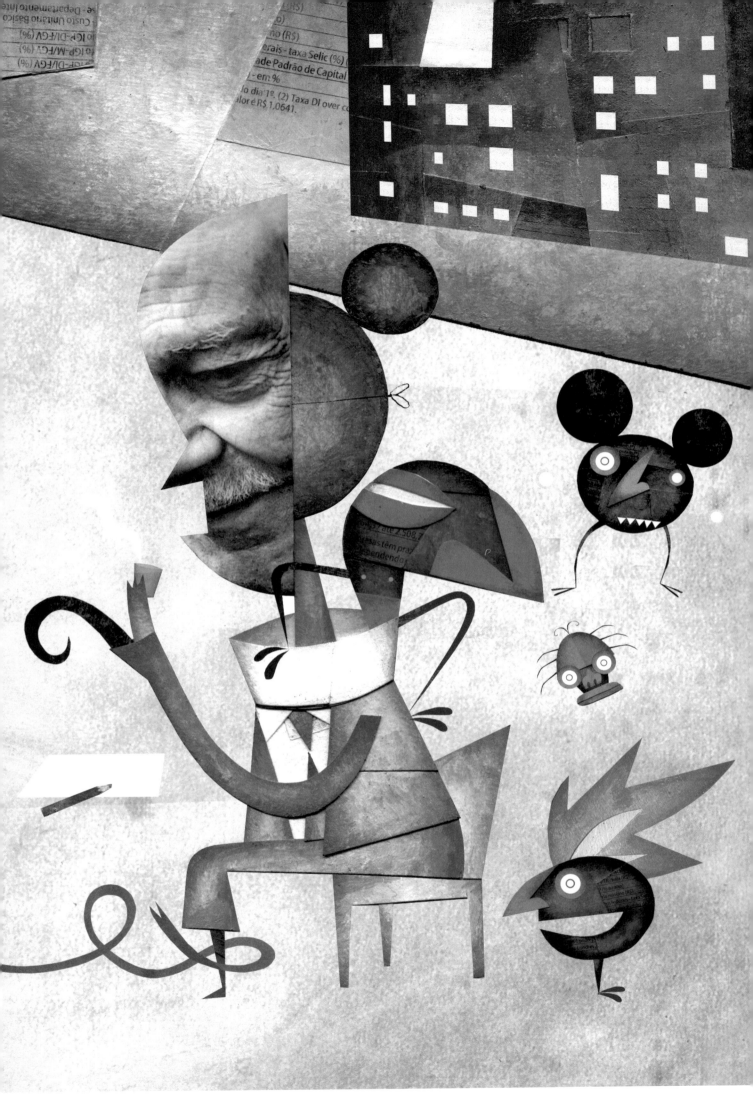

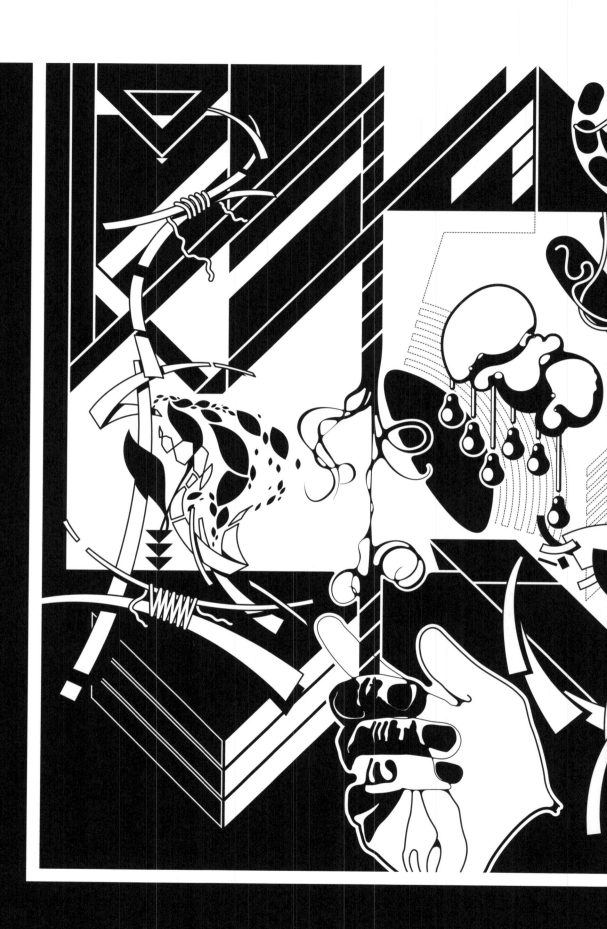

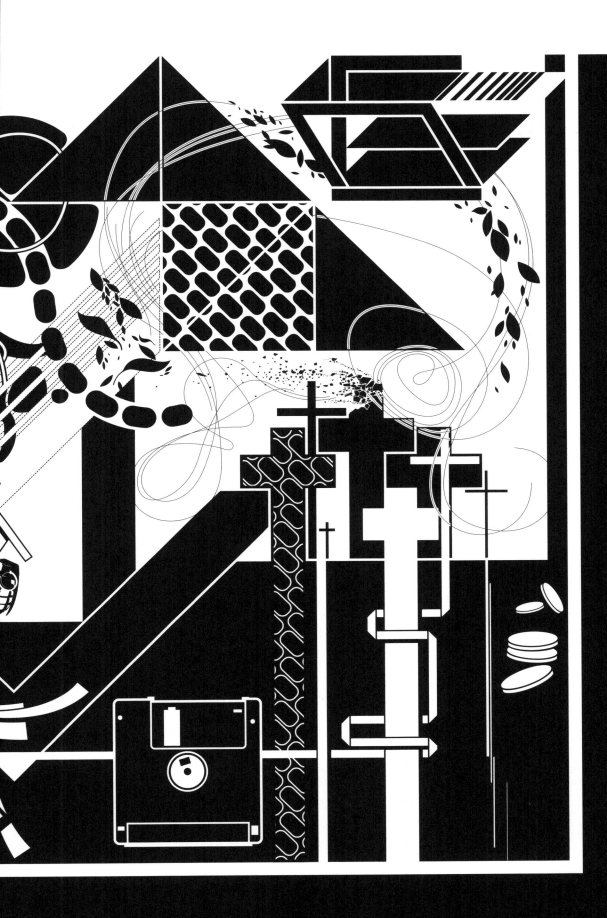

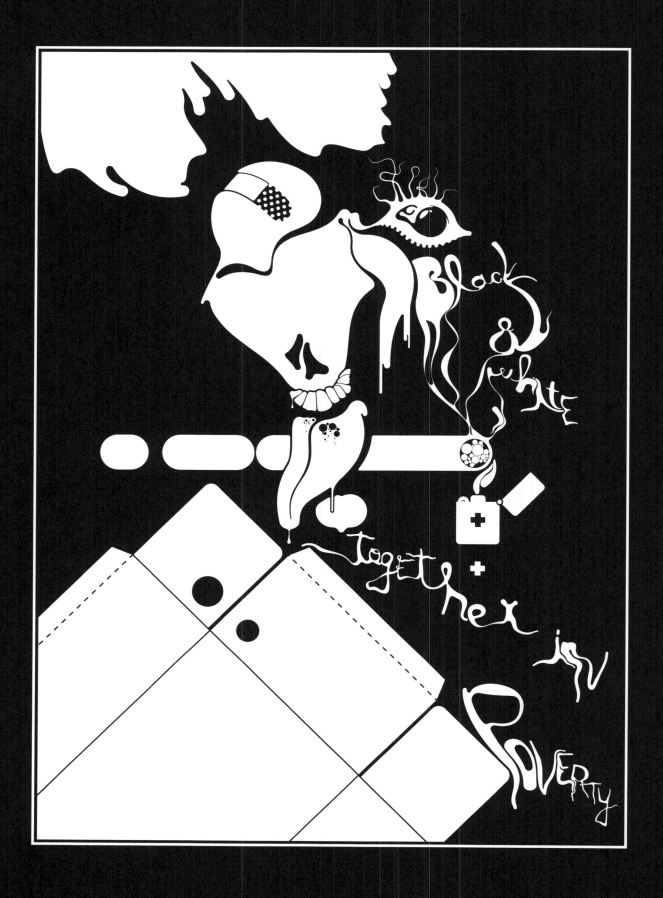

montanha inteira removida

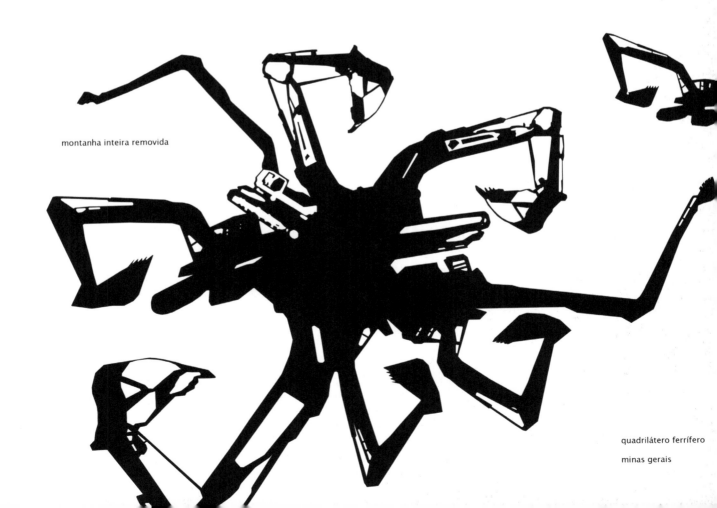

quadrilátero ferrífero

minas gerais

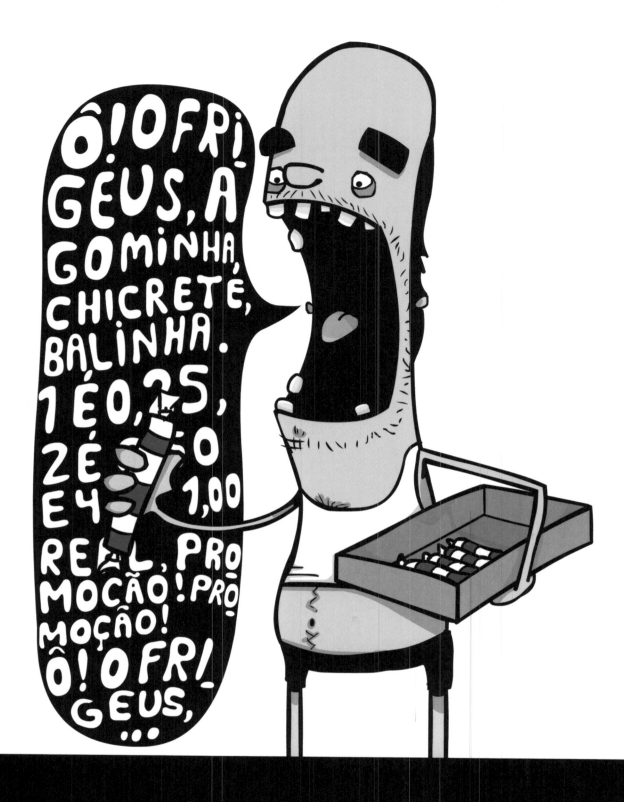

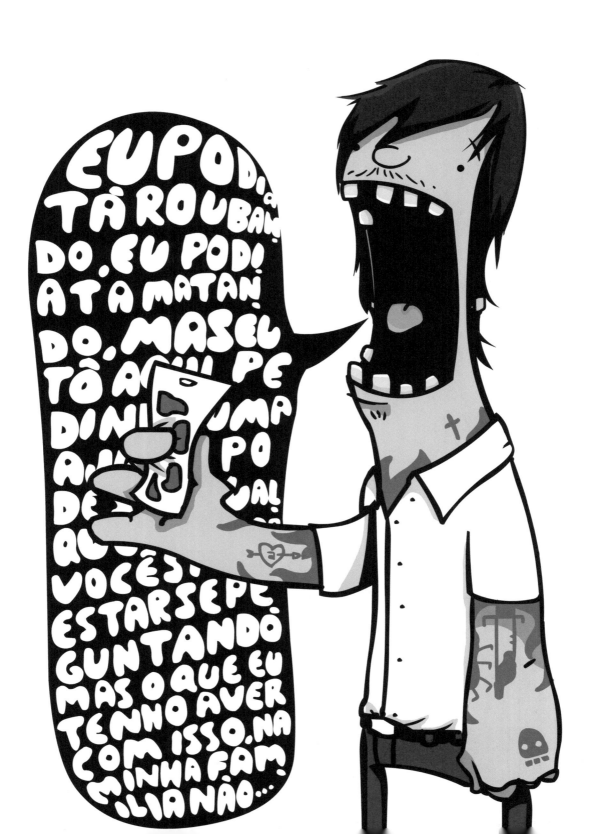

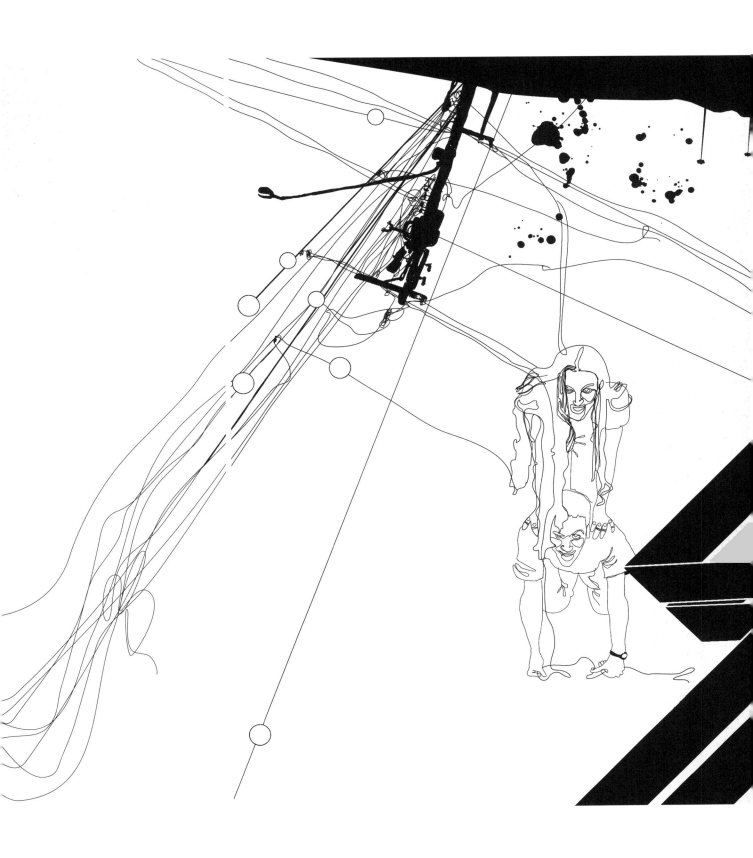

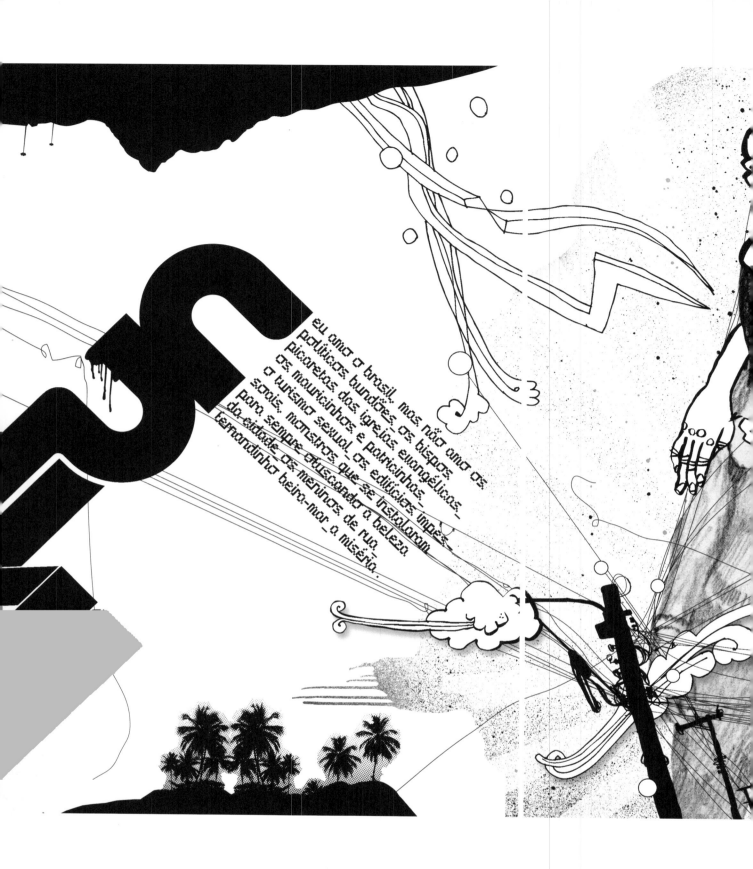

eu amo o brasil, mas não amo os políticos bundões, os bispos picaretas das igrejas evangélicas, os mauricinhos e patricinhas, o turismo sexual, os edifícios impessoais, monstros que se instalaram para sempre ofuscando a beleza da cidade, os meninos de rua, fernandinho beira-mar, a miséria.

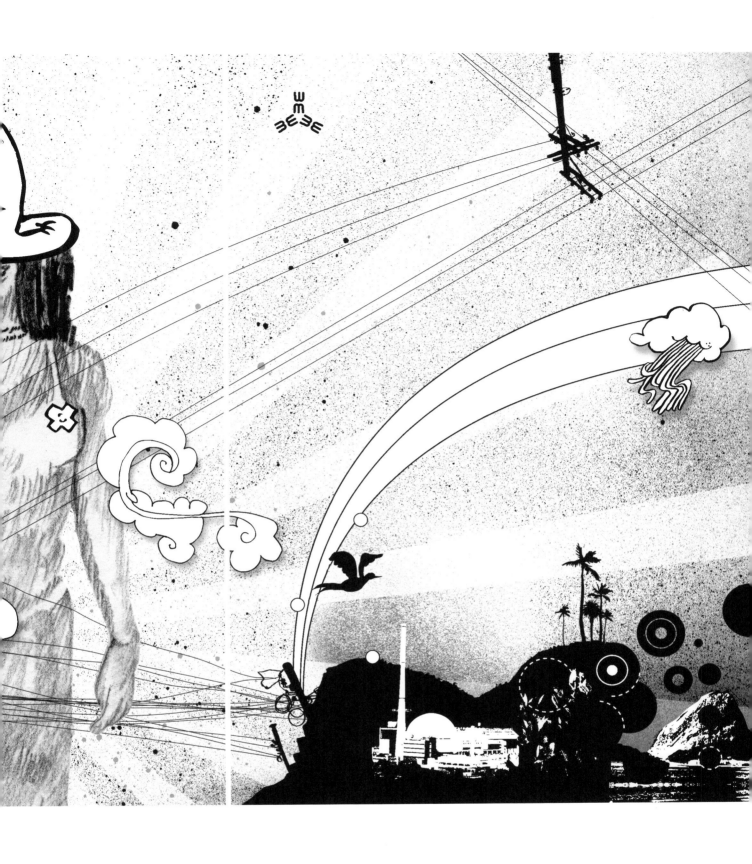

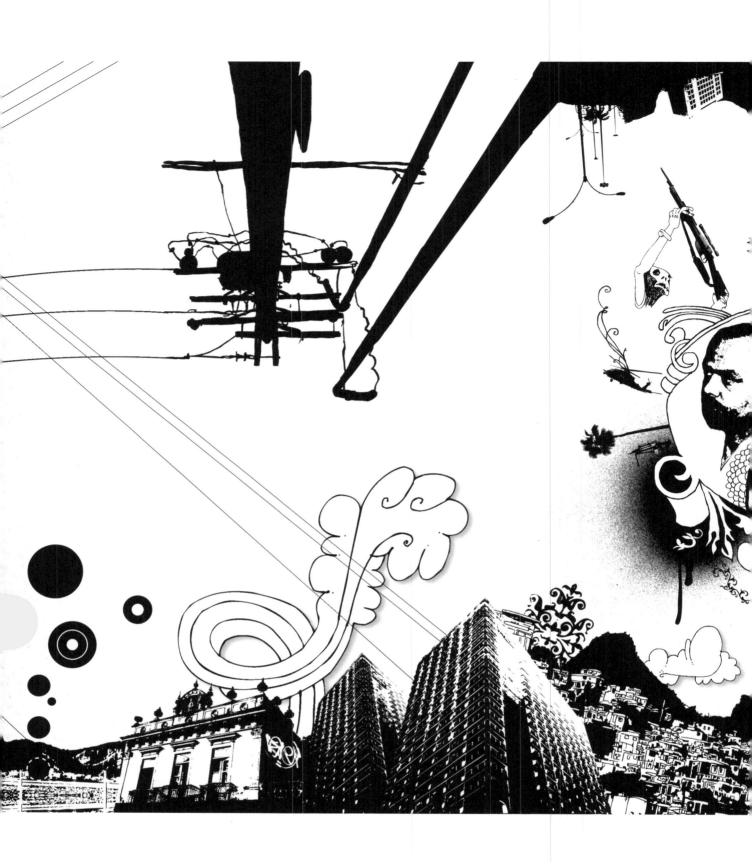

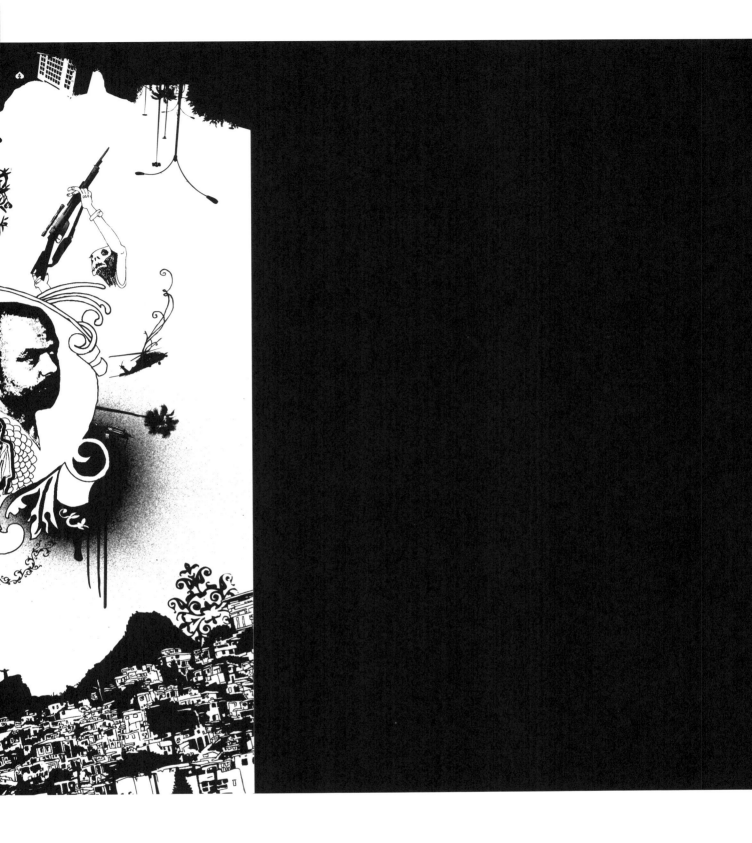

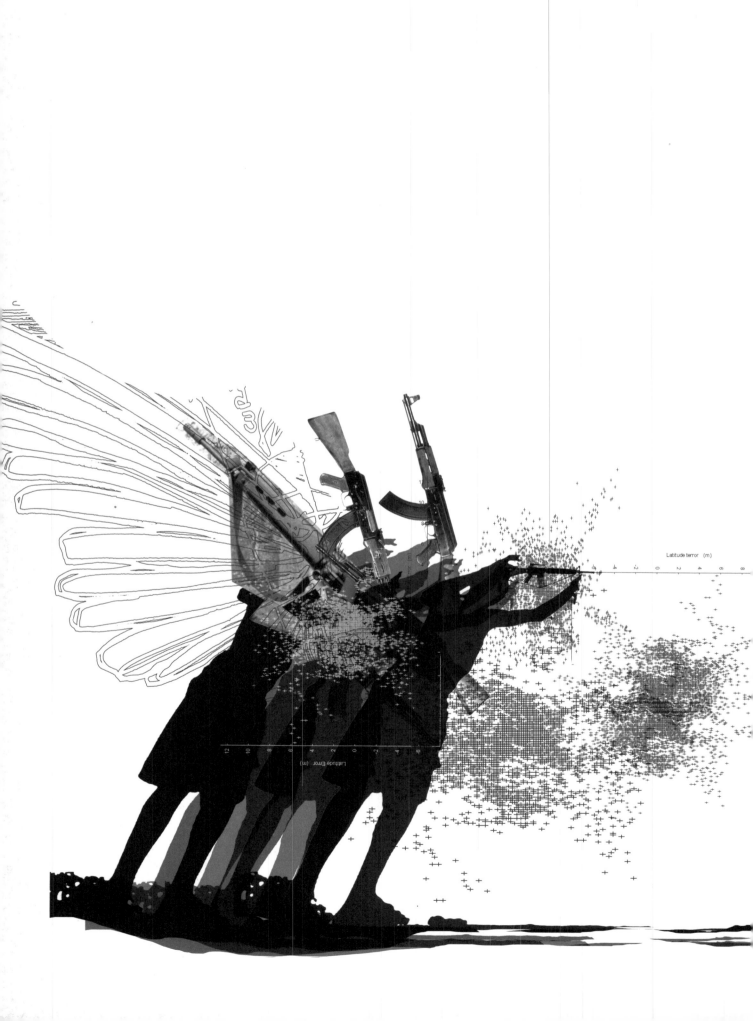

Latitude terror (m)

Latitude Error (m)

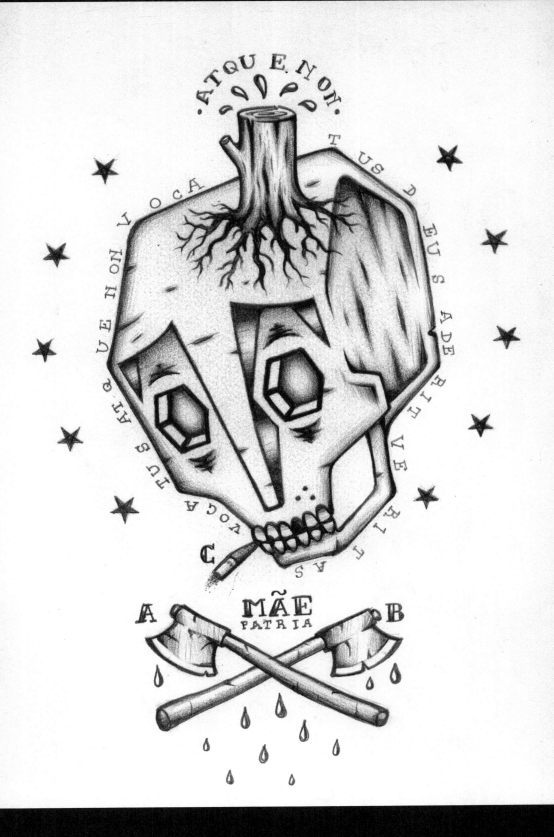

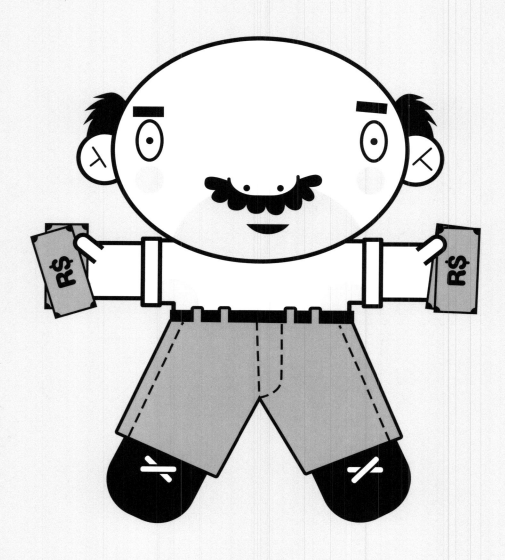

_Sr.José is happy, because today he received
his payment from one entire month of hard work.

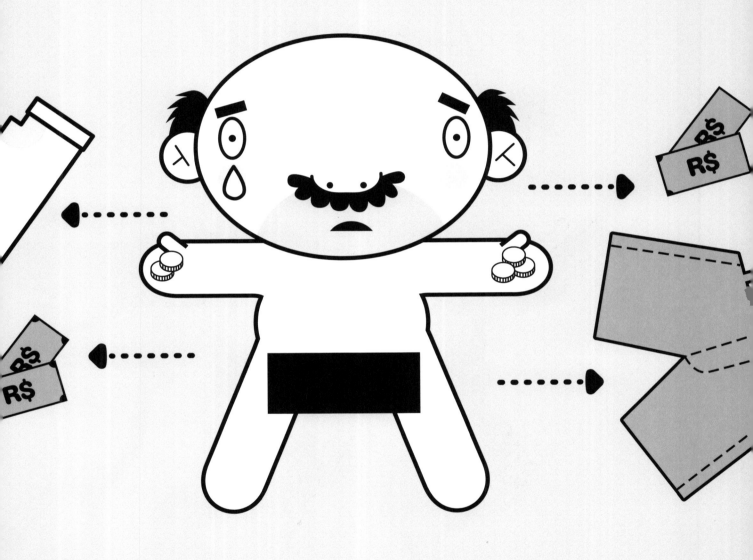

_ Hey Sr.José, did you forget the taxes?
You´re so funny Sr.José

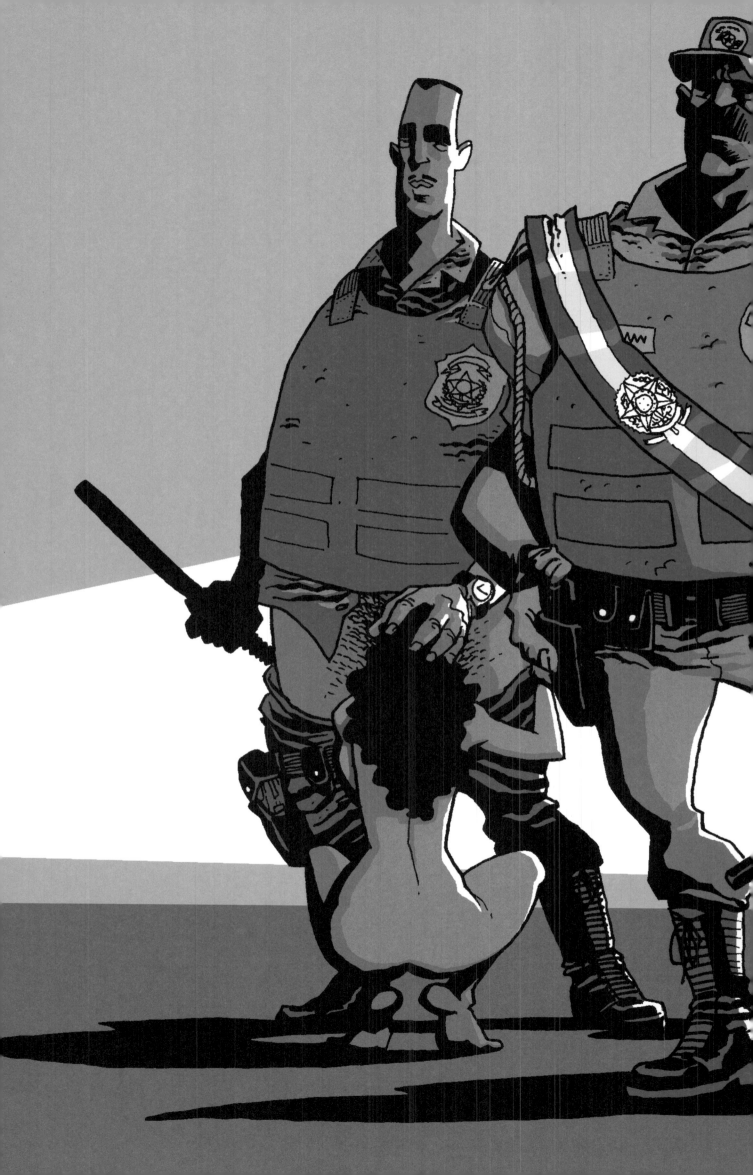

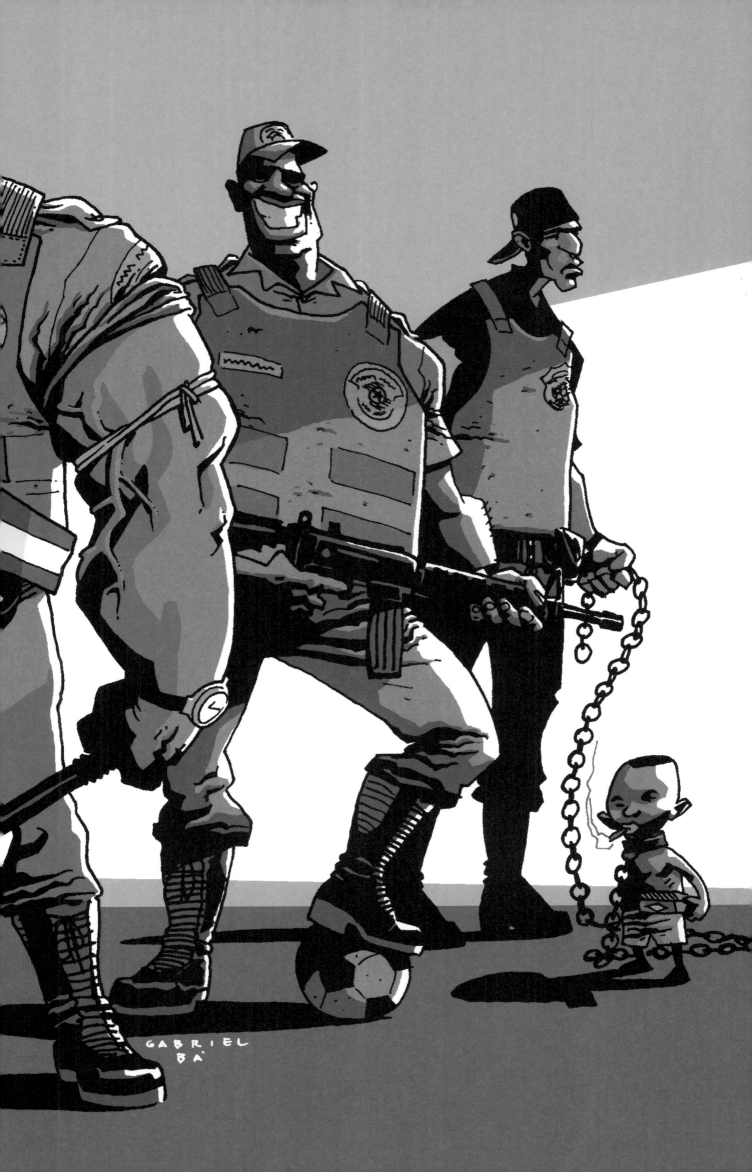

DUNCE

Brazil's

LACK
OF EDUCATION
DRIVES OUR CHILDREN TO EMPTINESS.

BURRO
CRACIA

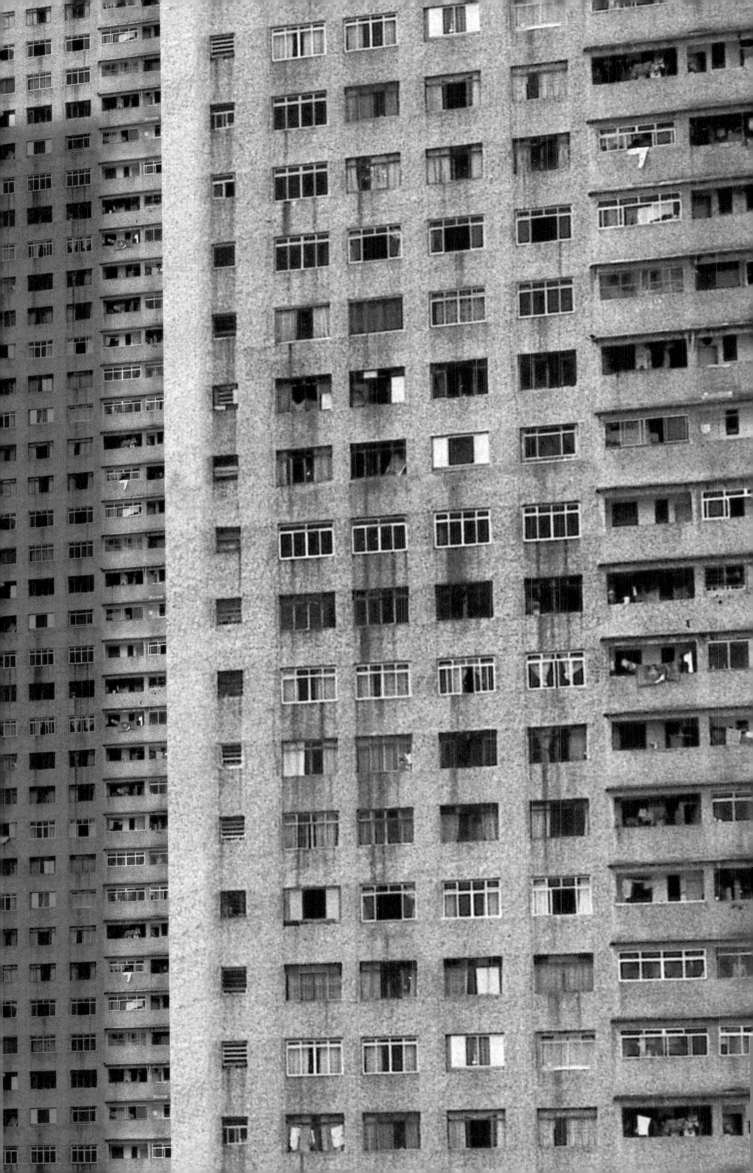

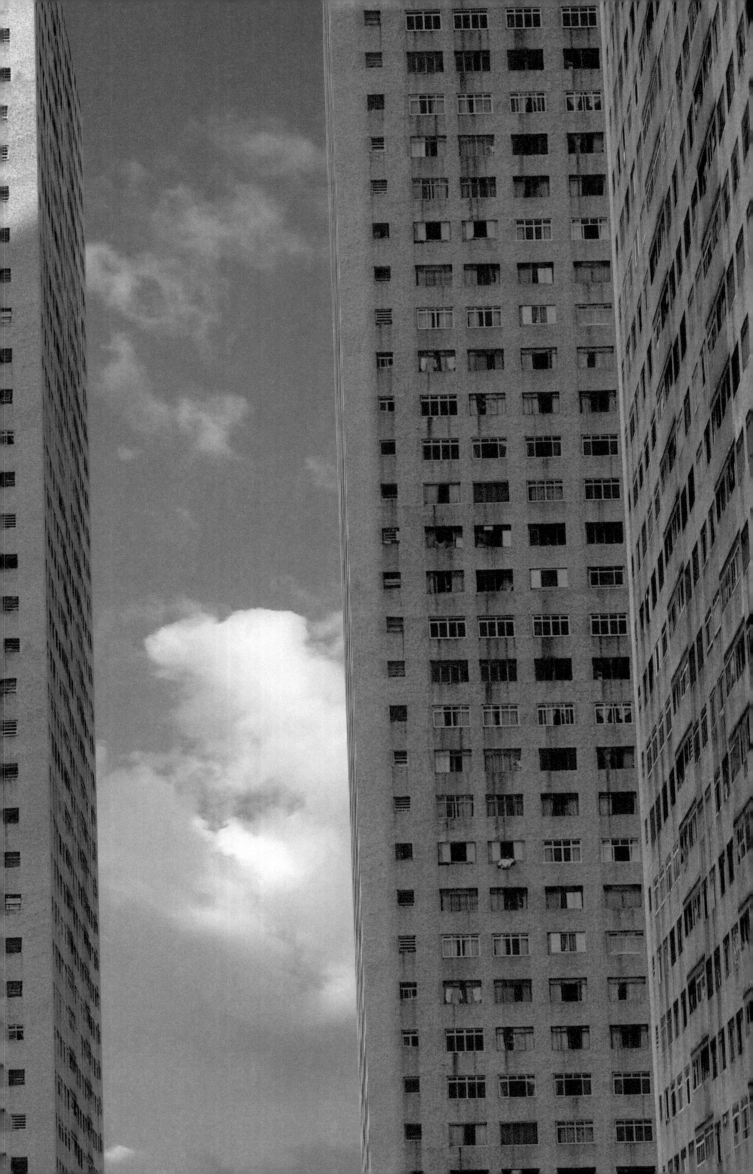

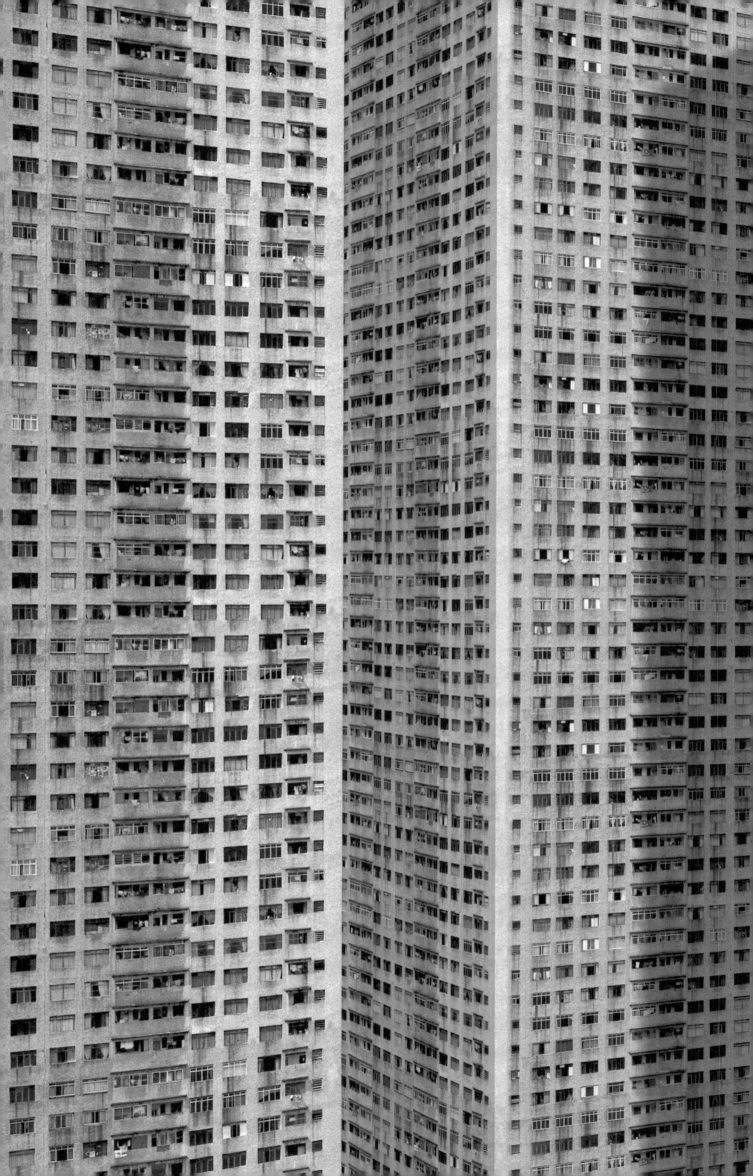

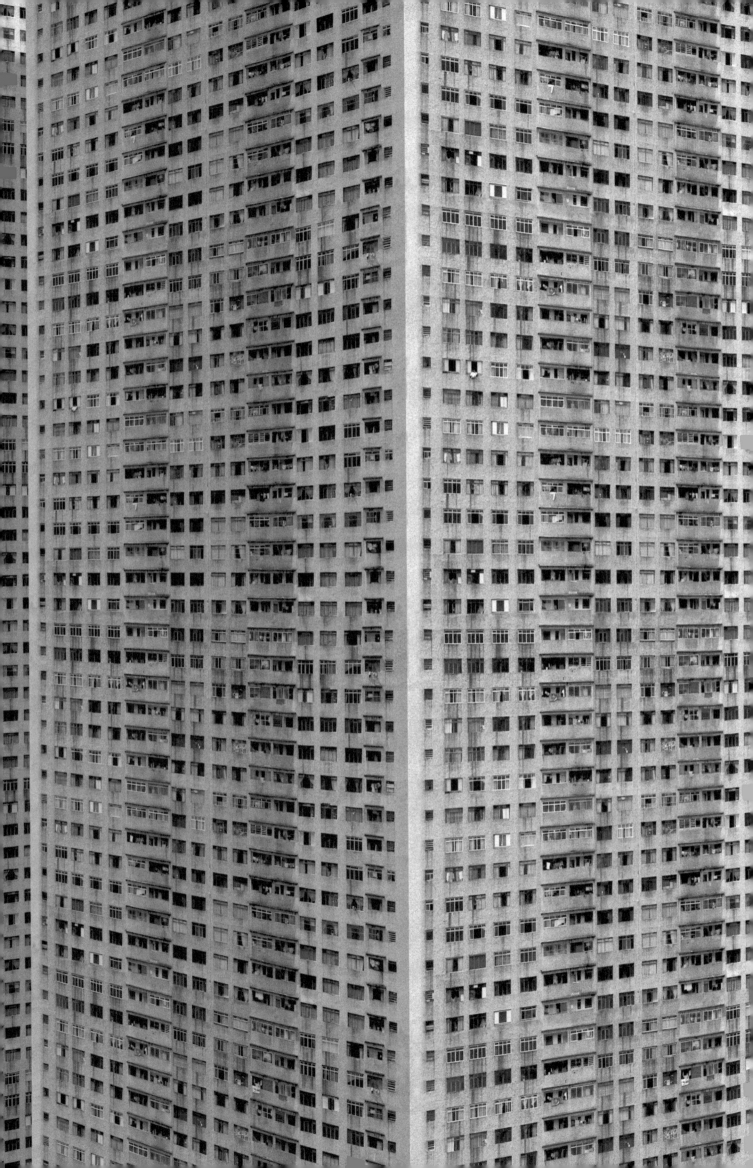

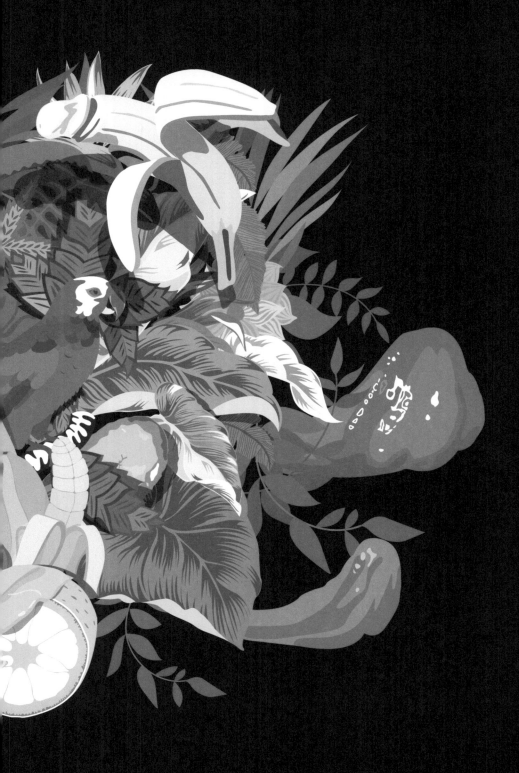

56

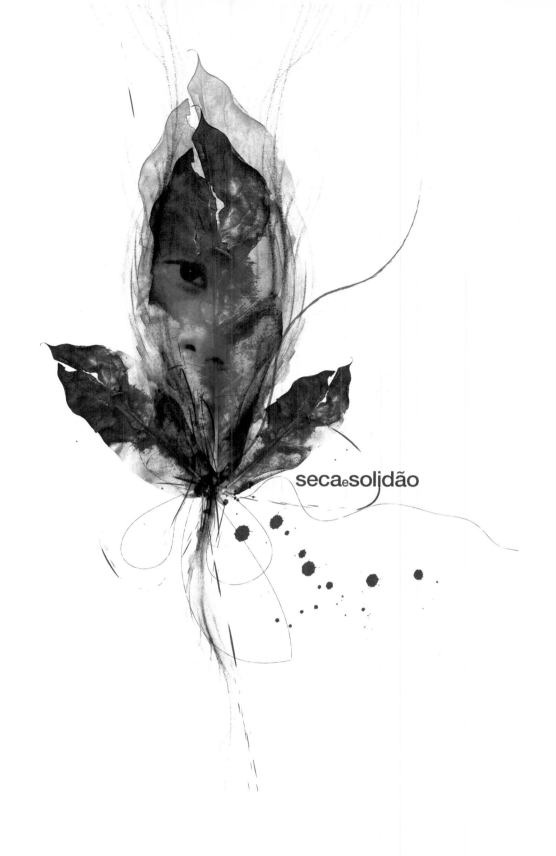

seca e solidão

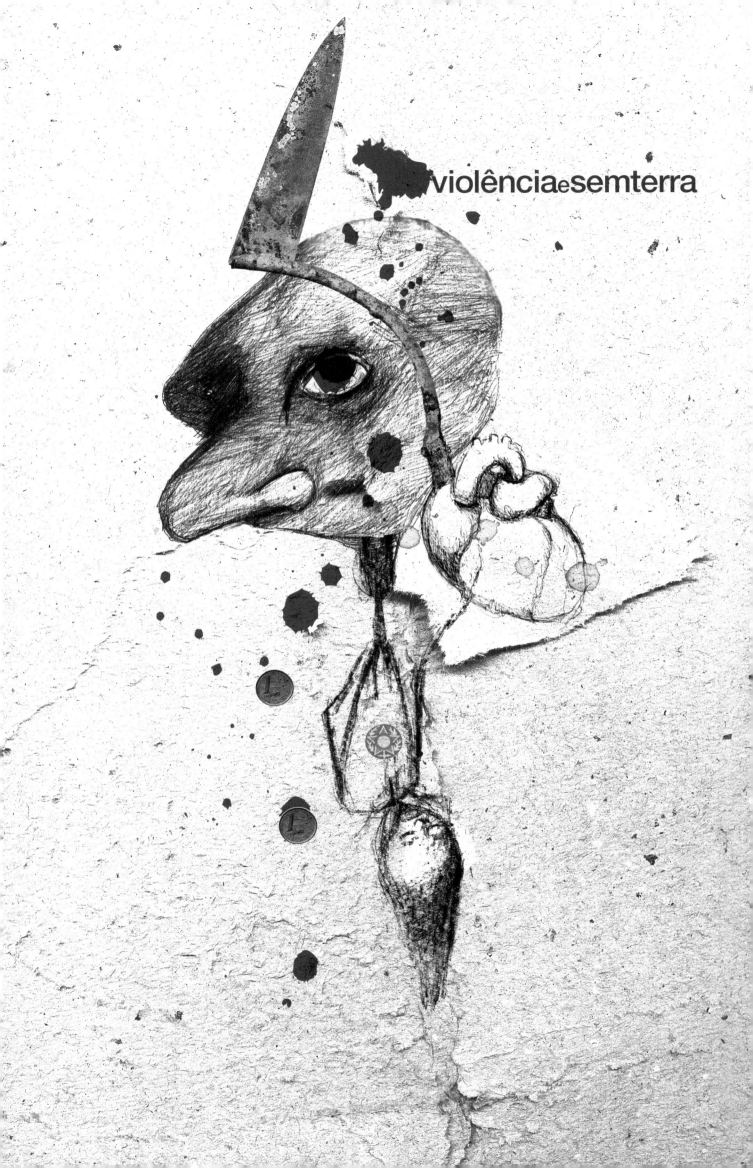

violência e sem terra

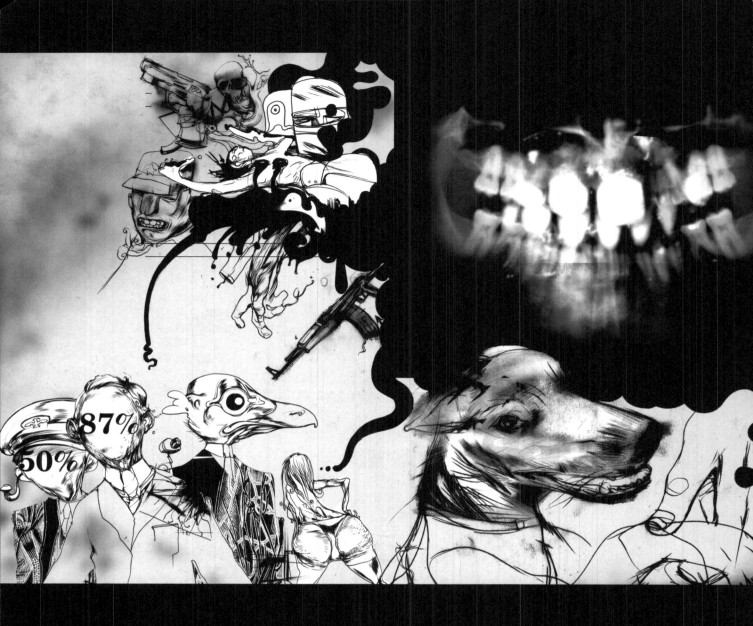

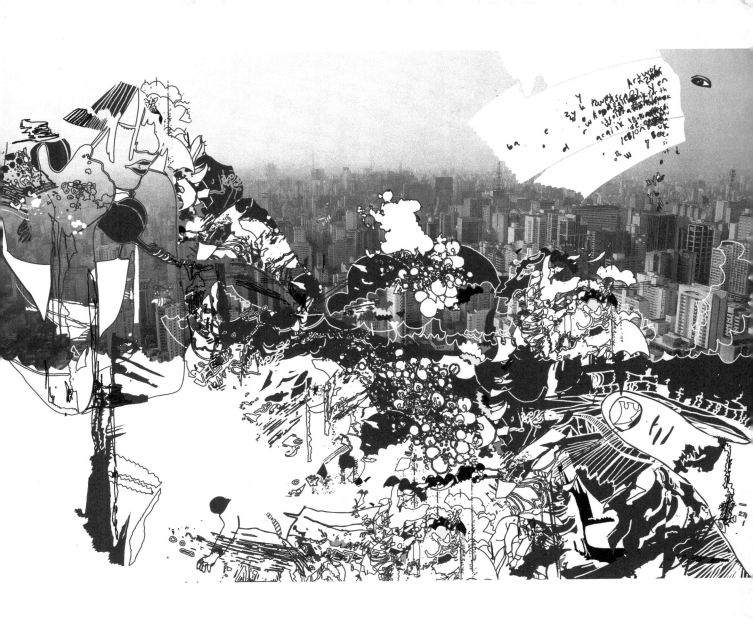

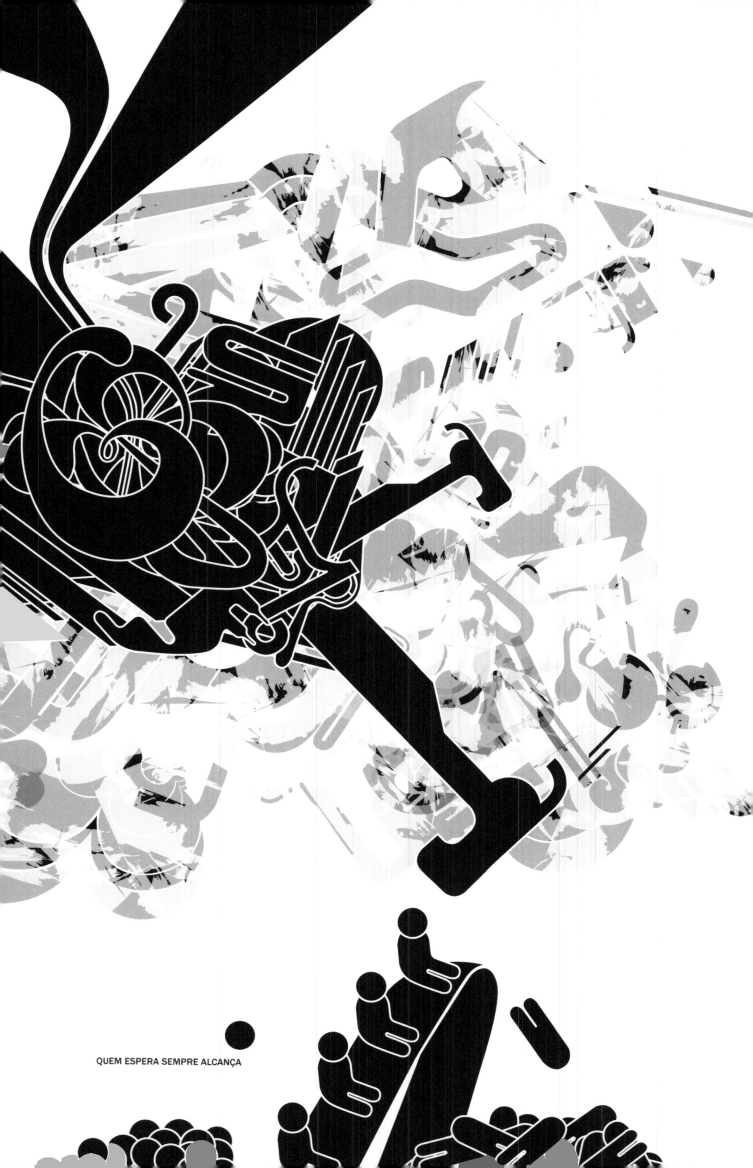

QUEM ESPERA SEMPRE ALCANÇA

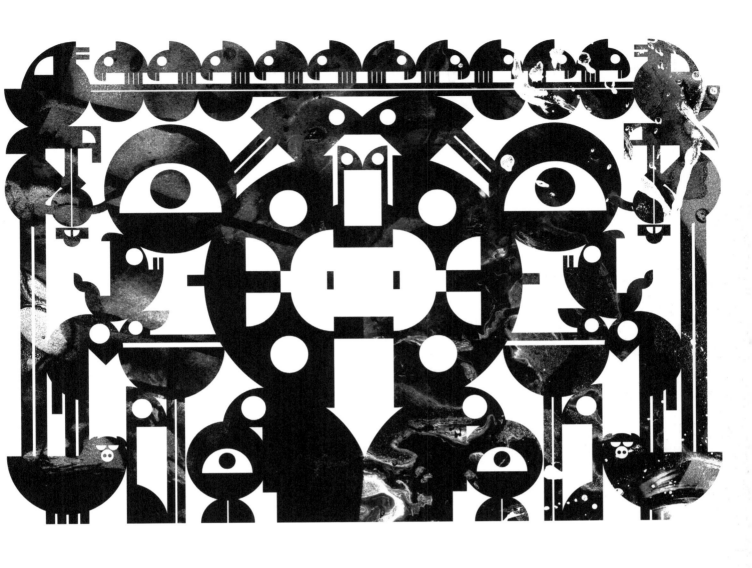

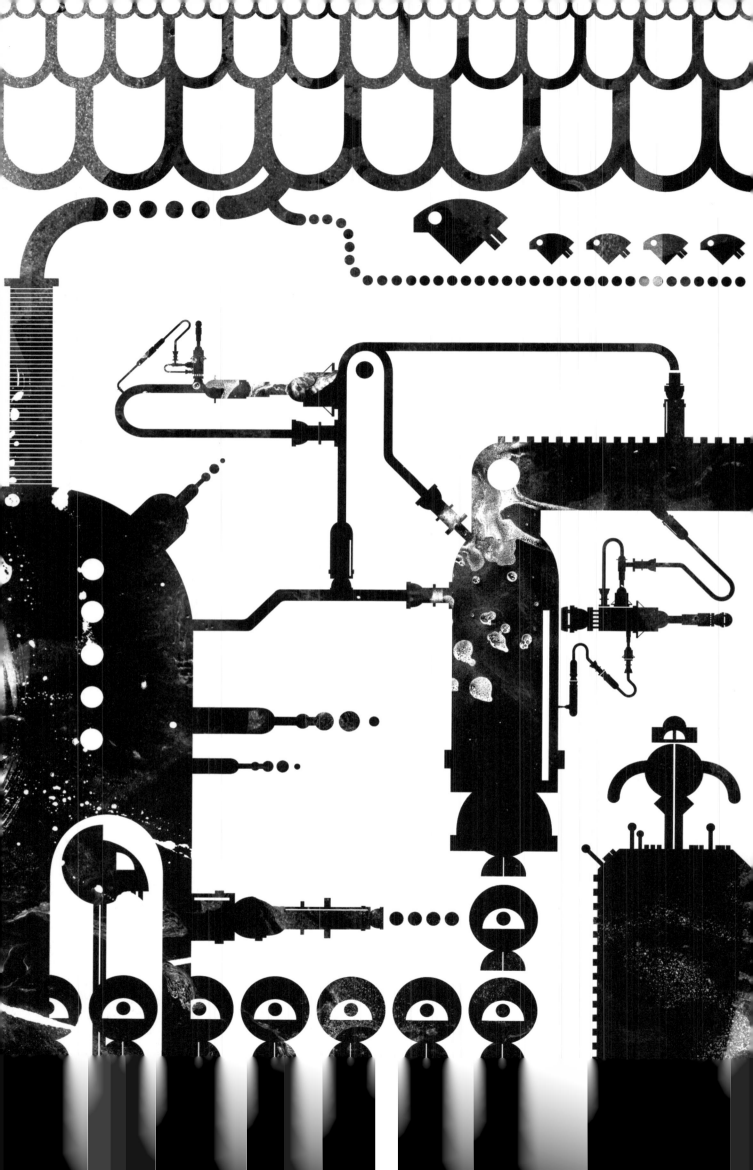

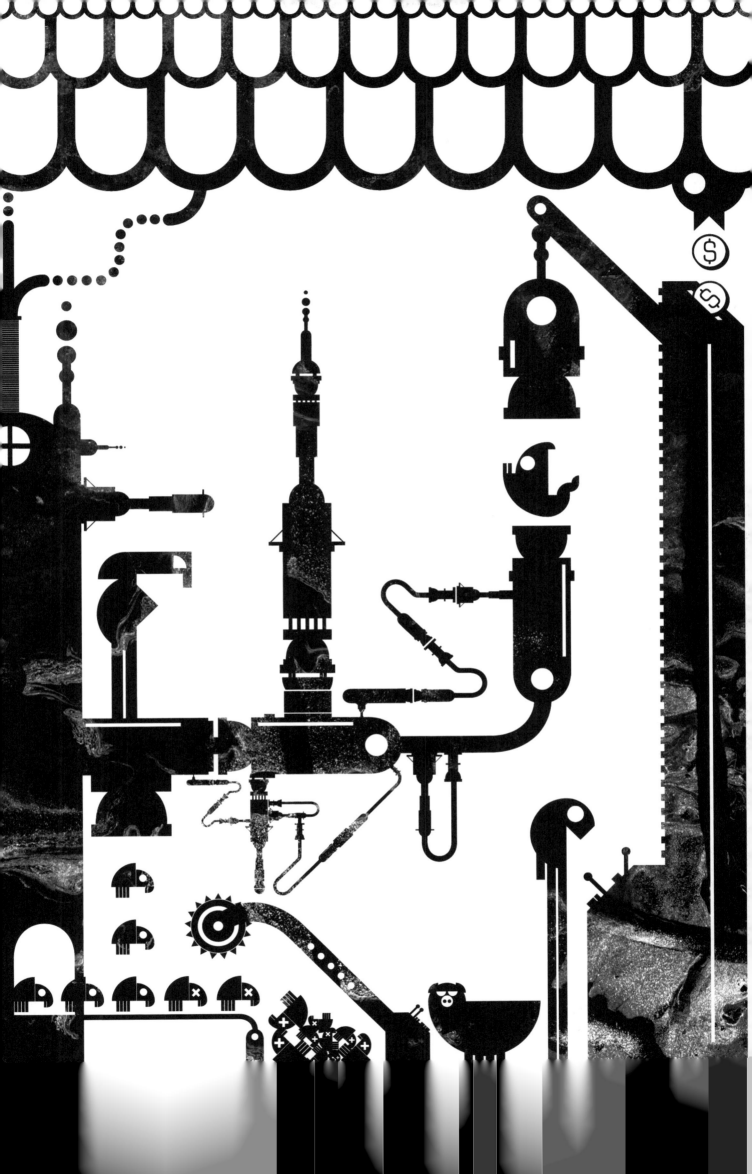

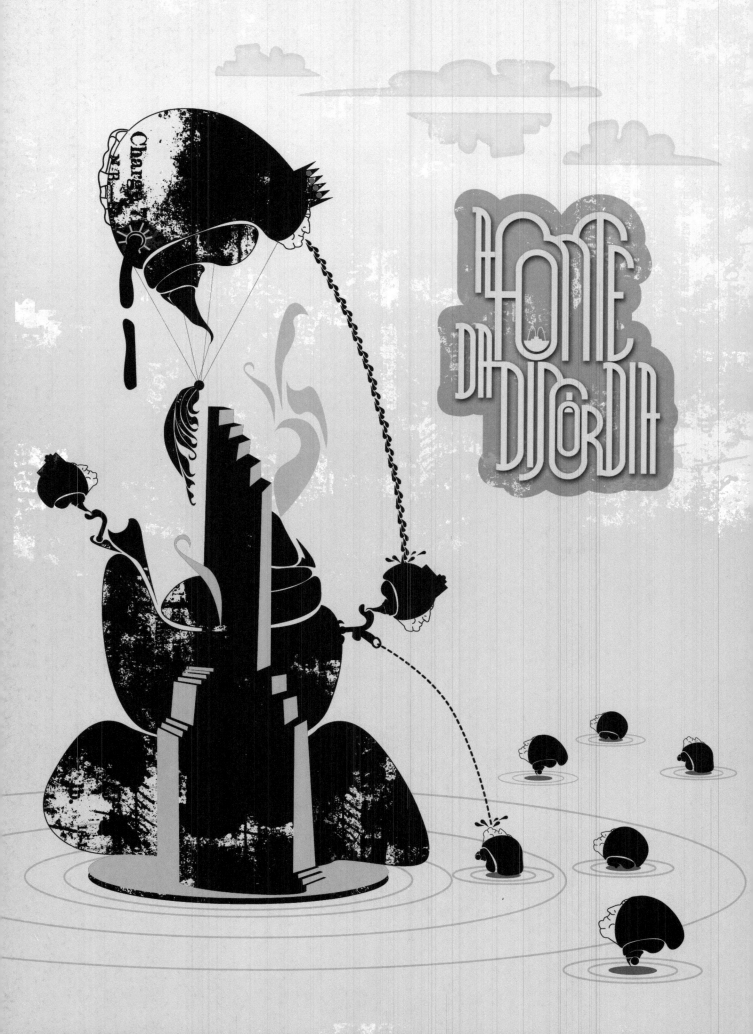

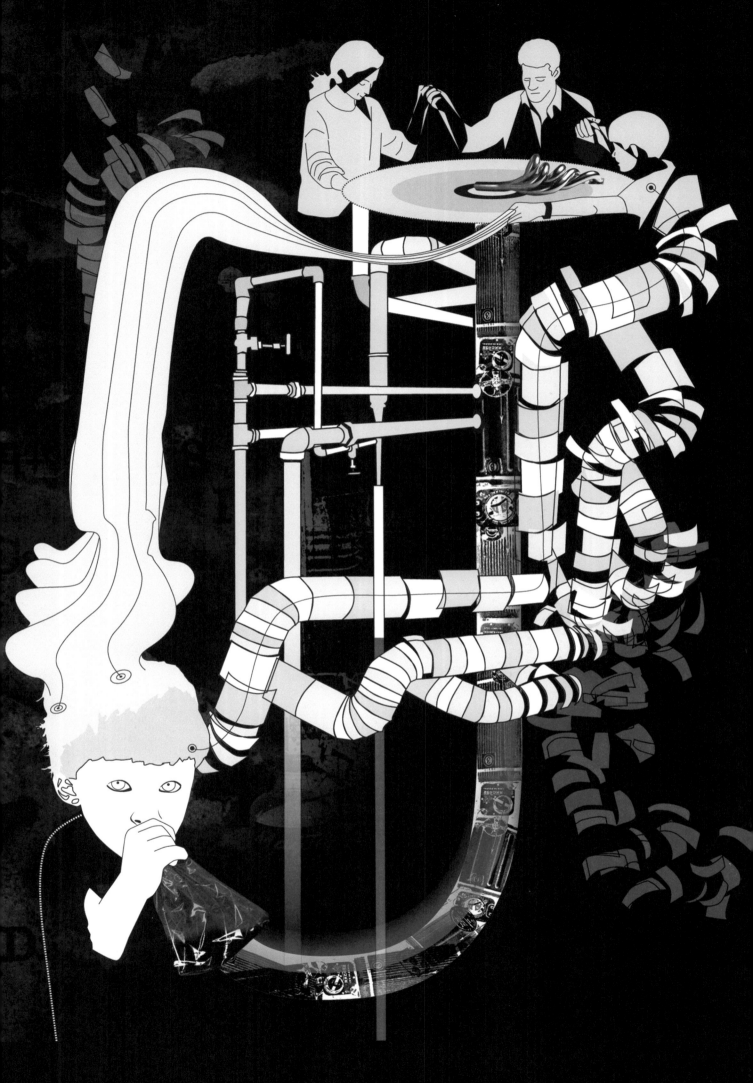

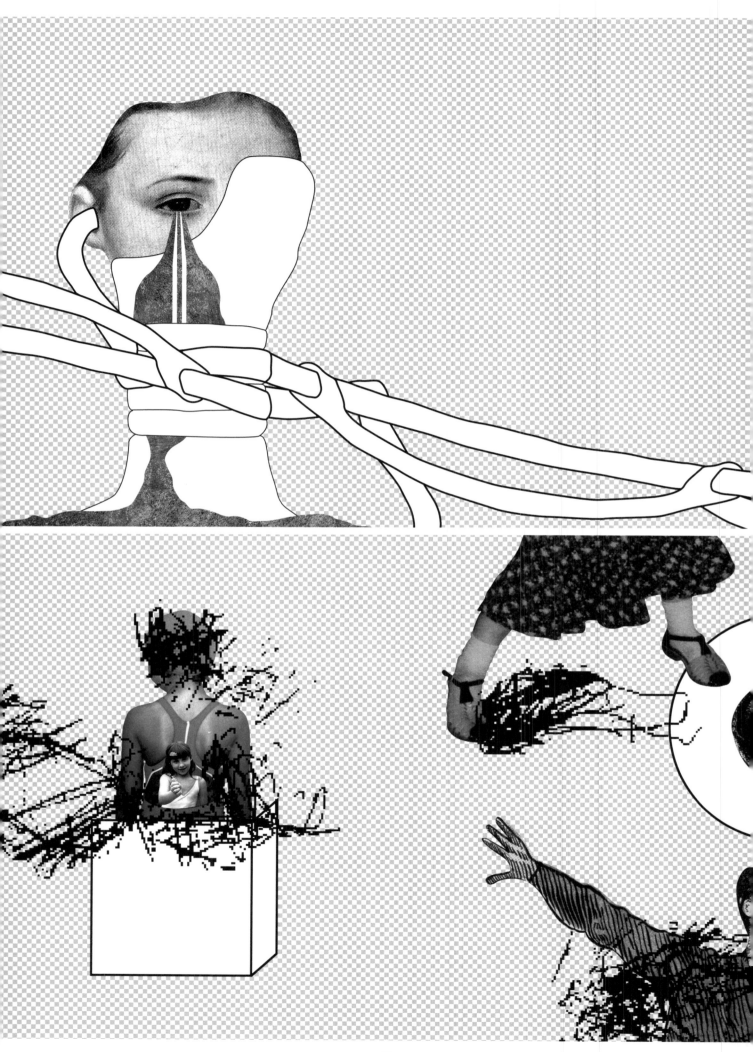

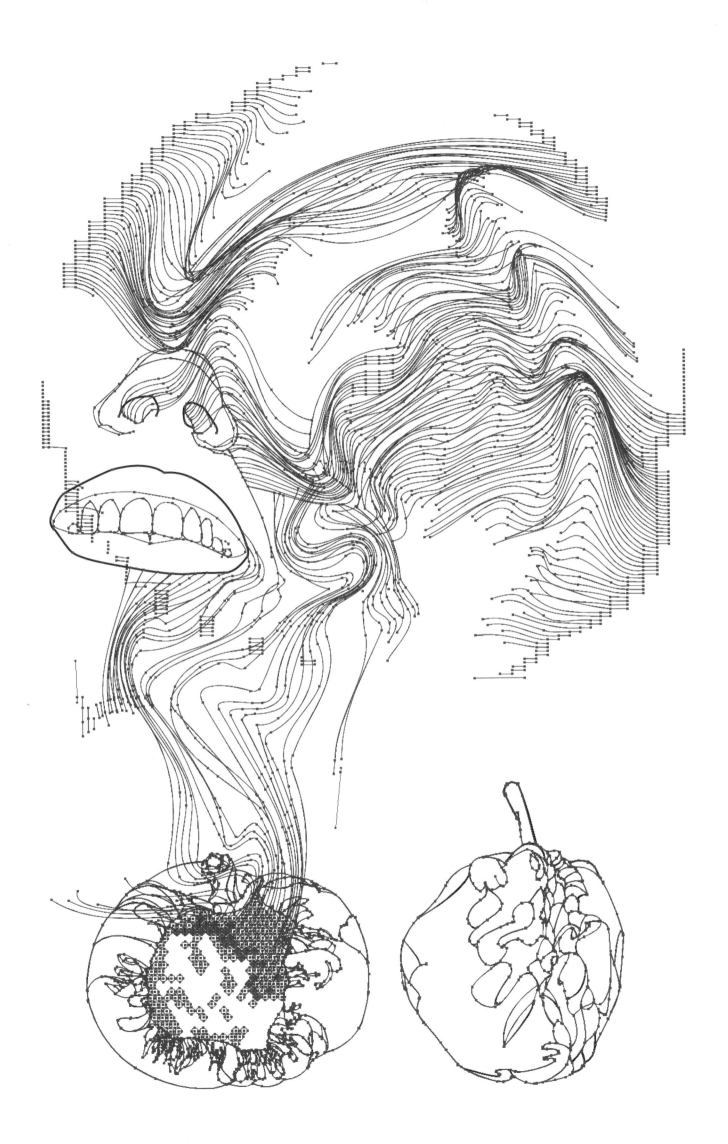

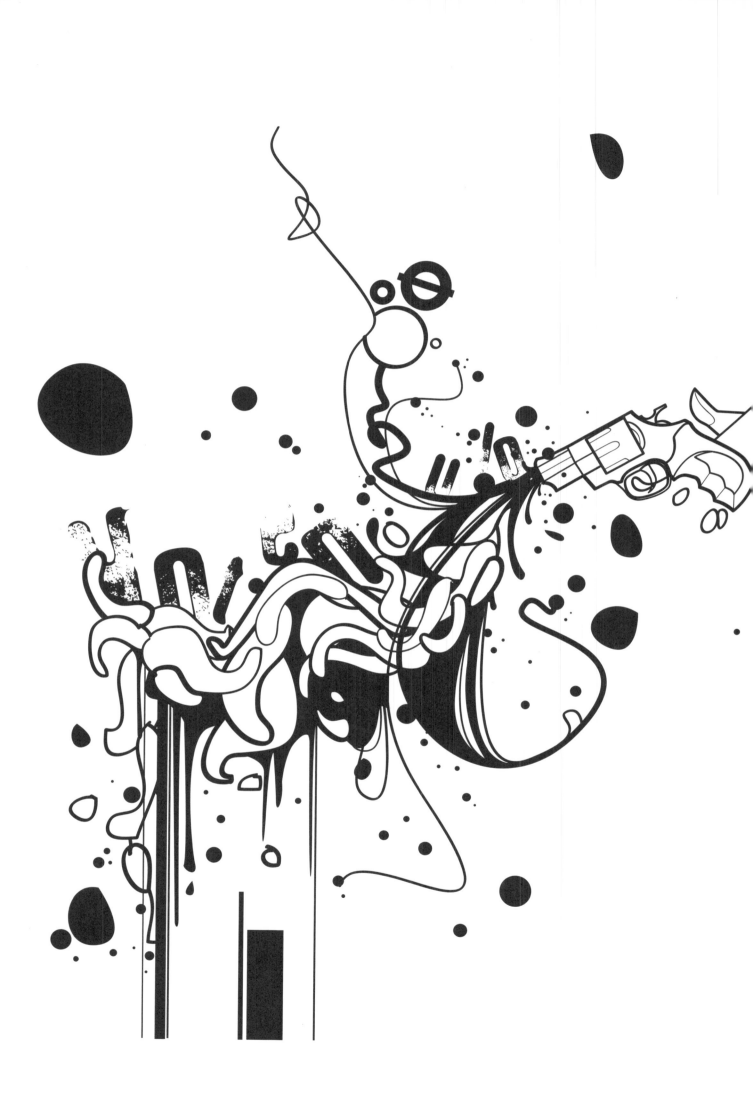

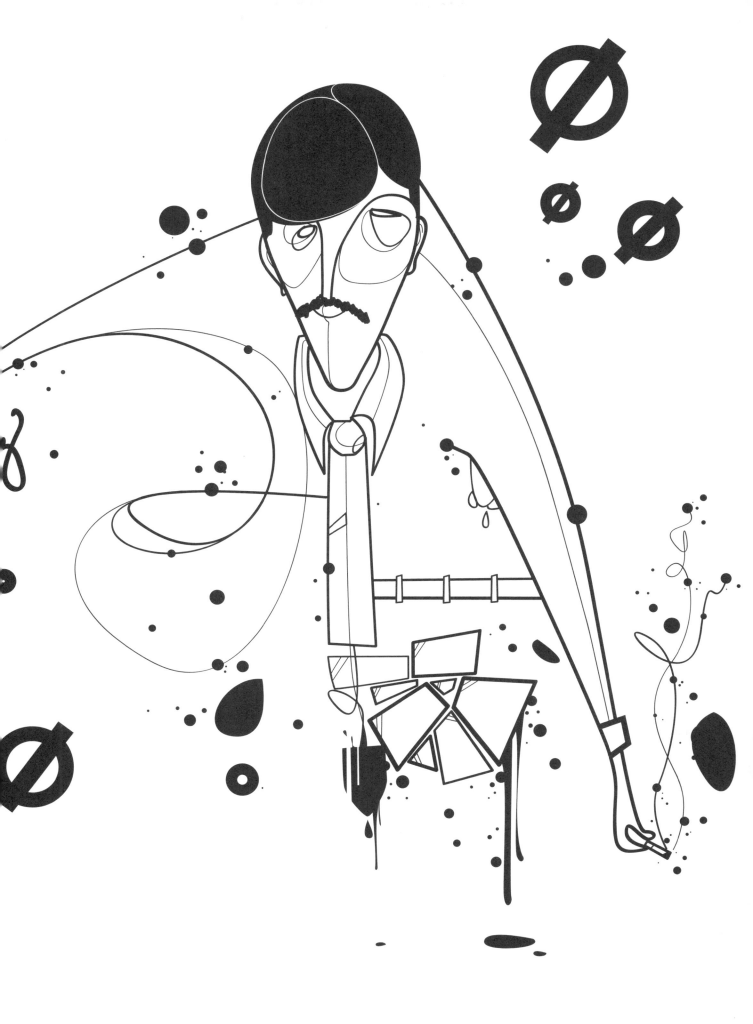

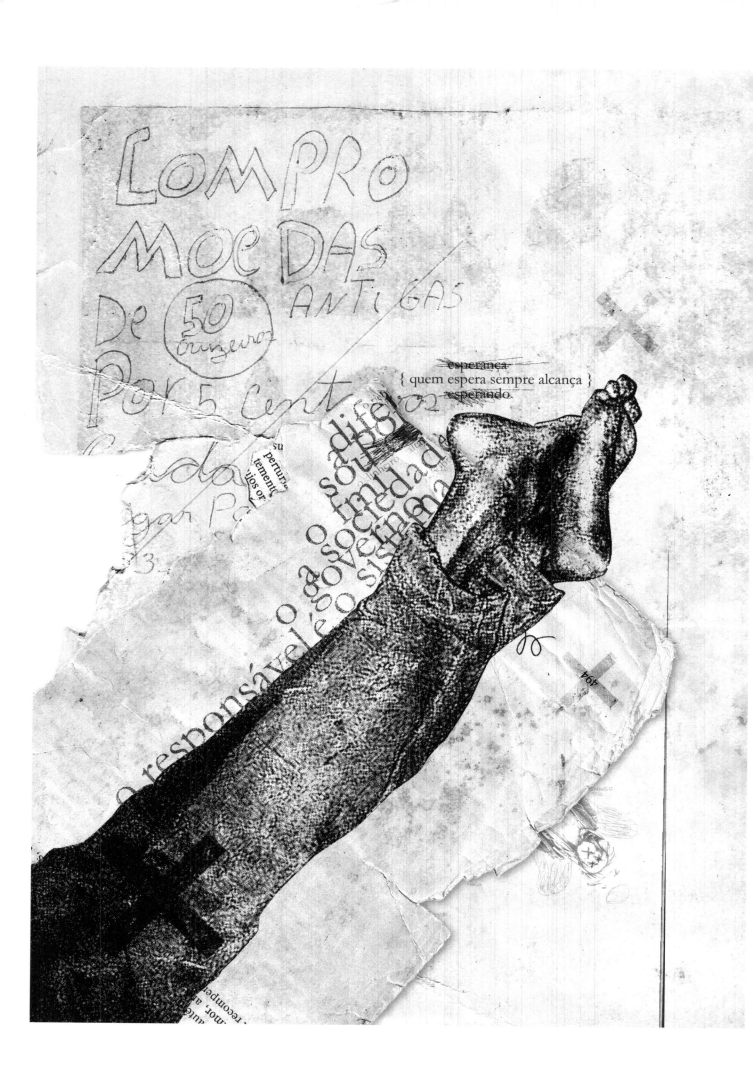

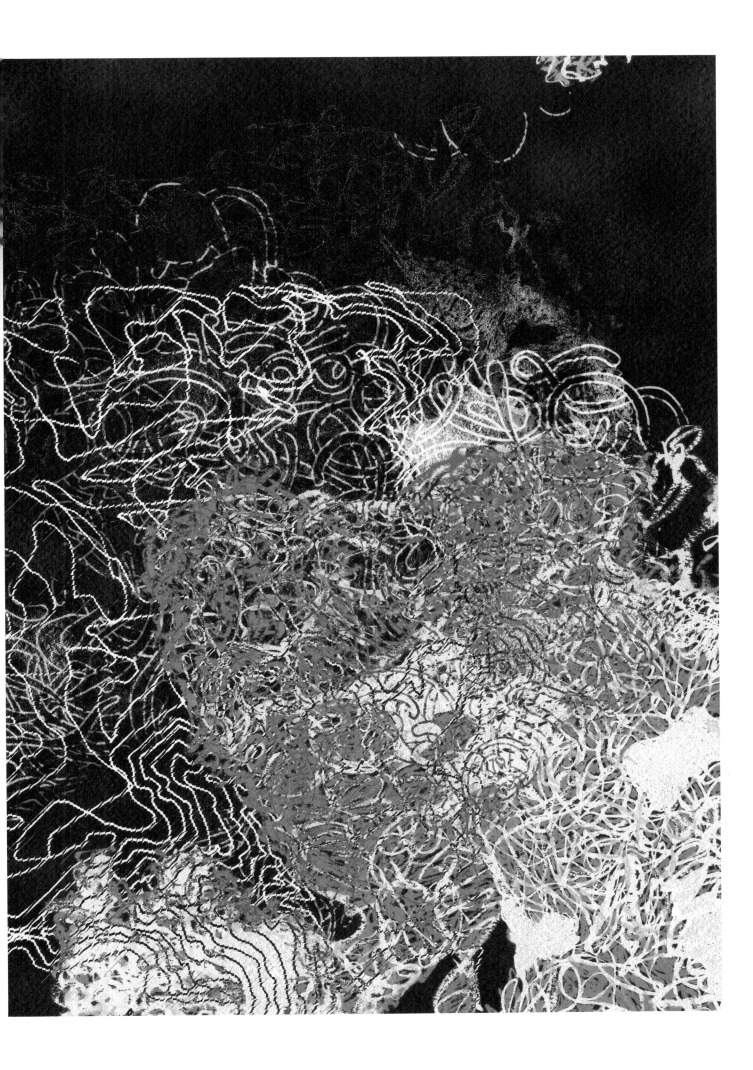

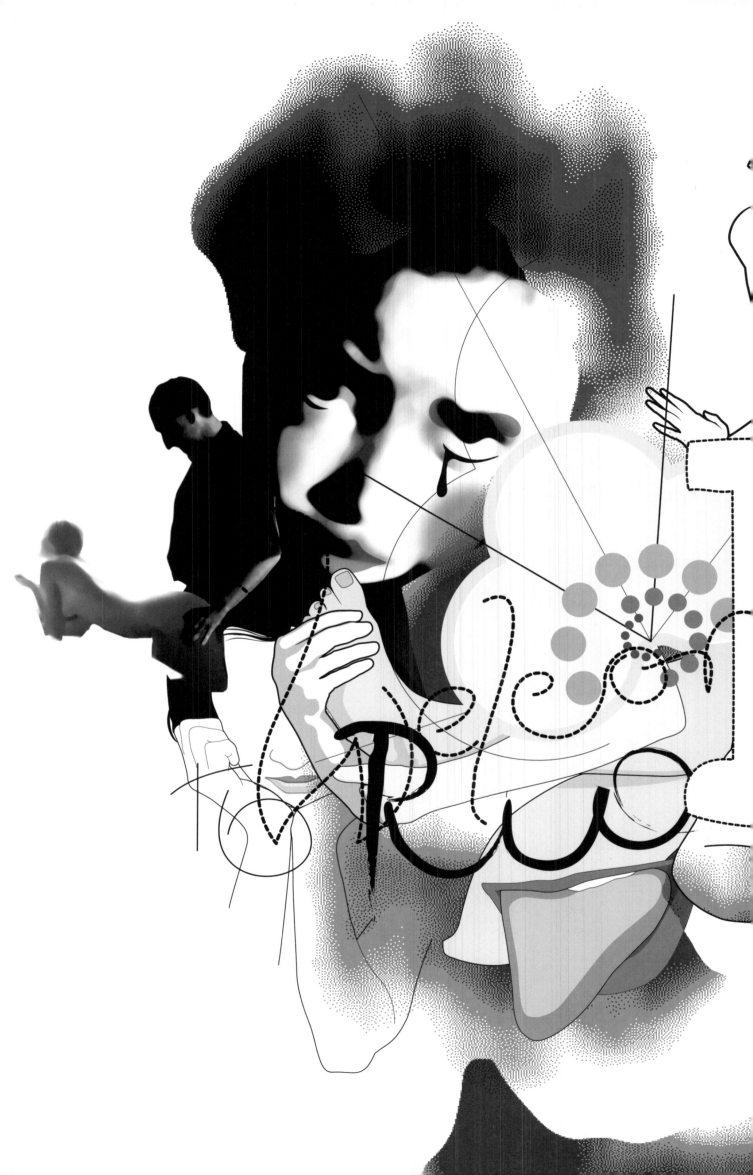

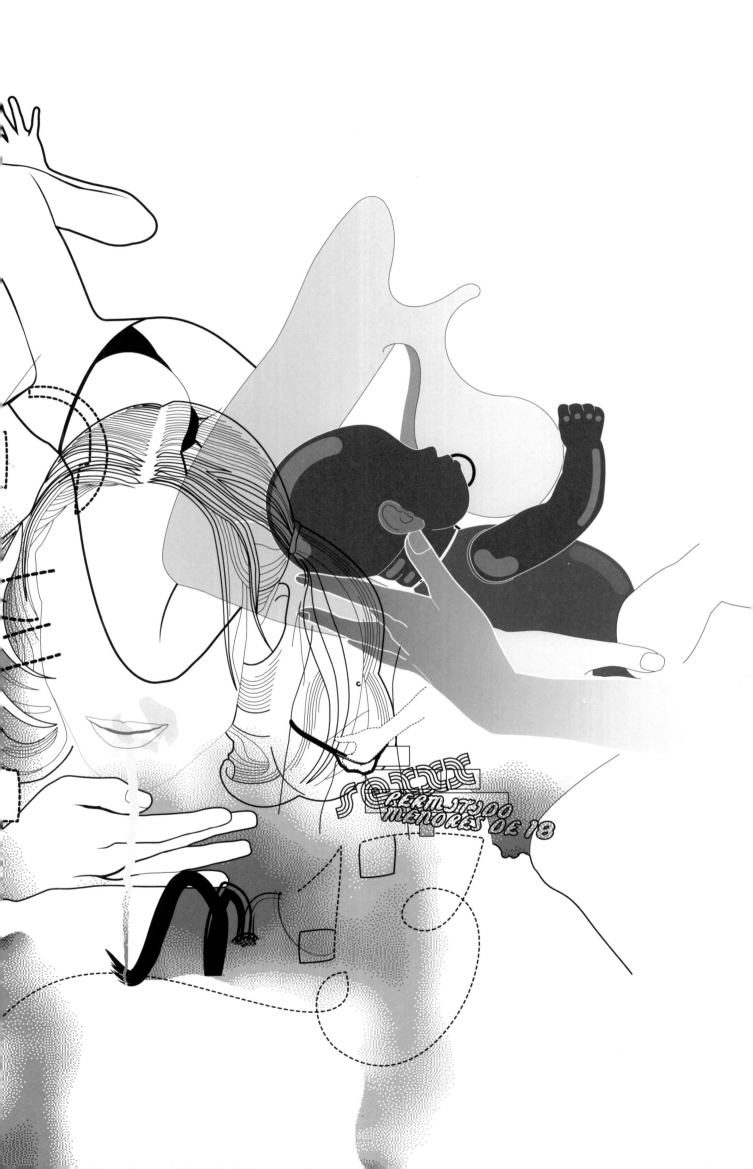

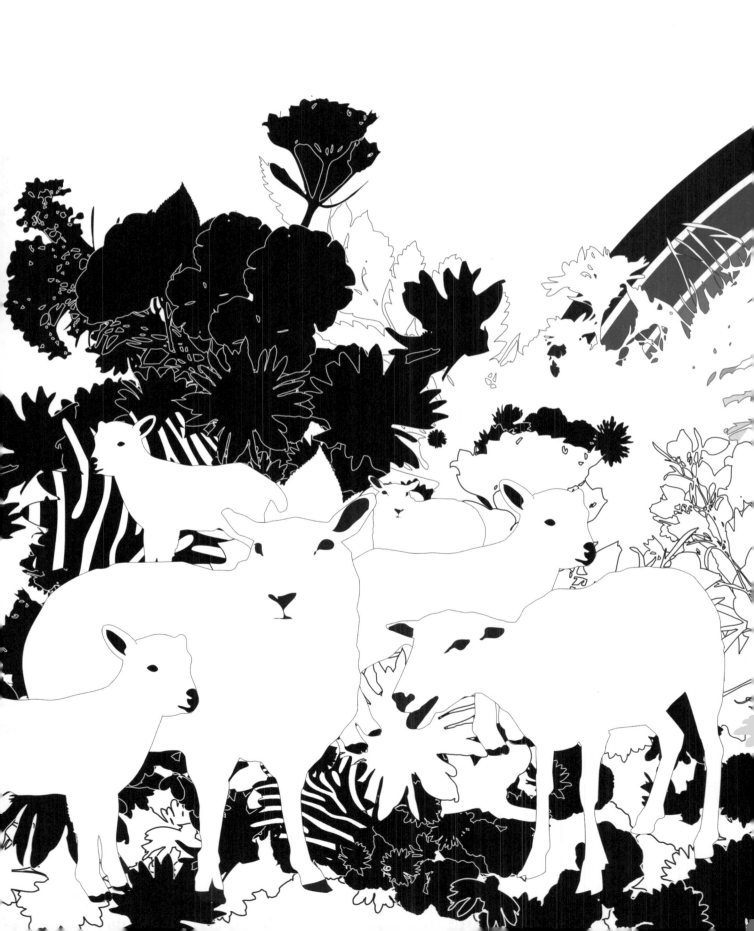

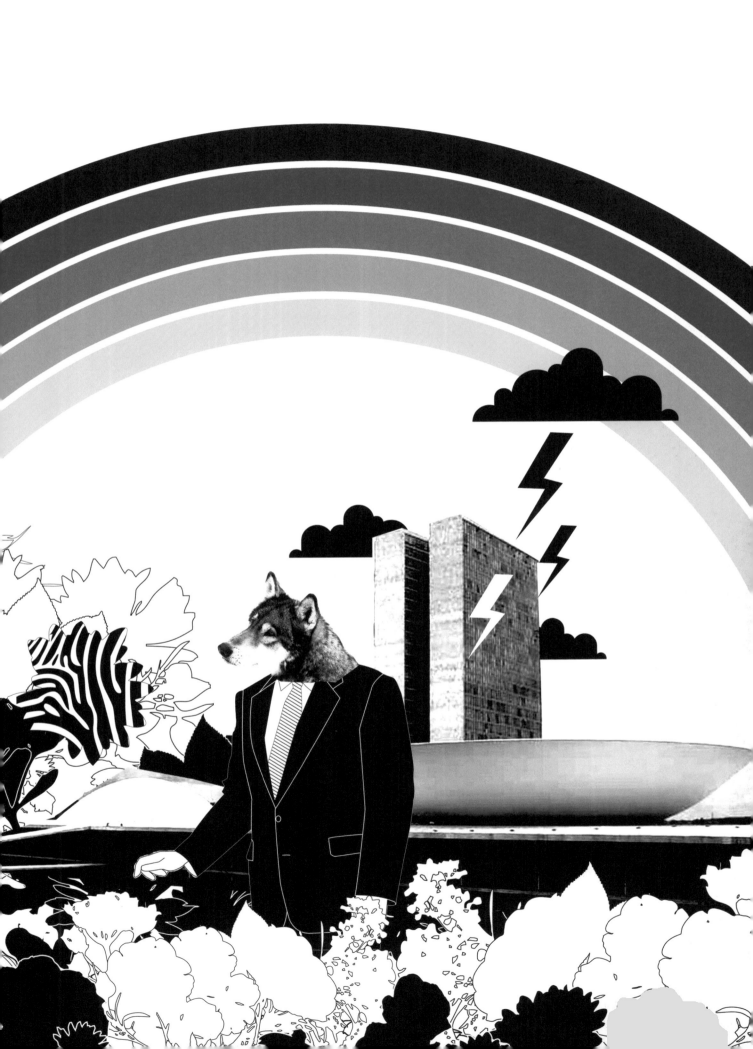

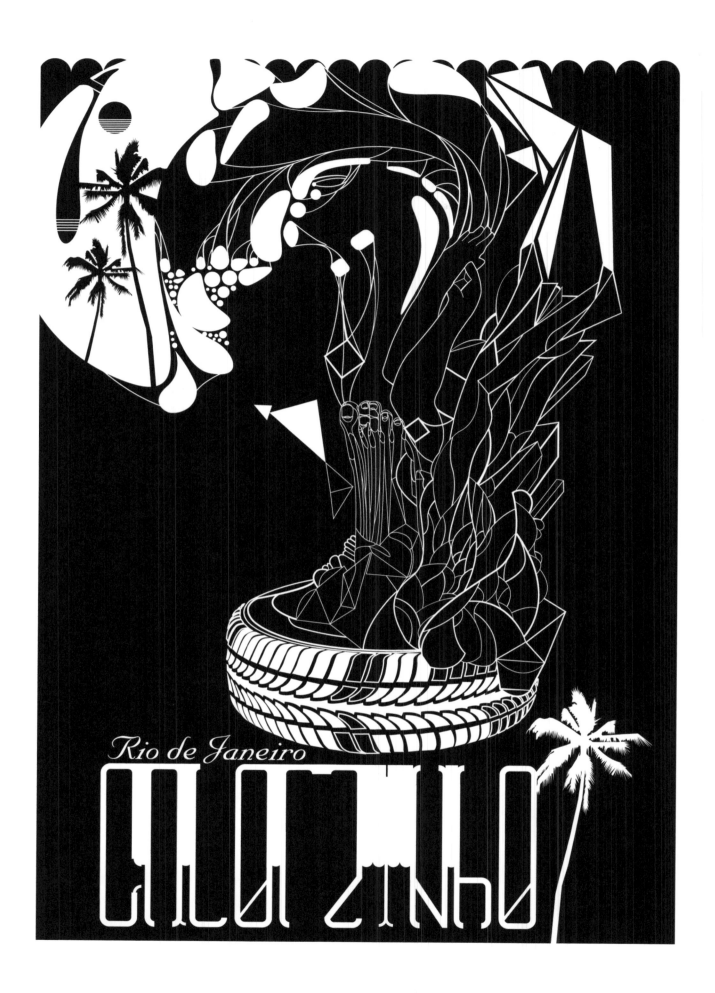

Rio de Janeiro

17 12 15 5 22

8 13 10 4

21 7 9 1 16

6 11 18 14 3

2 24 23 26 20 25

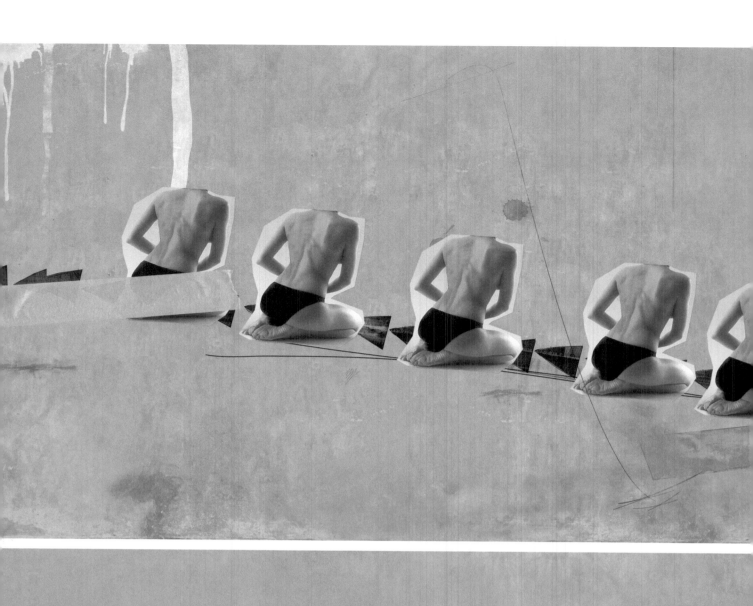

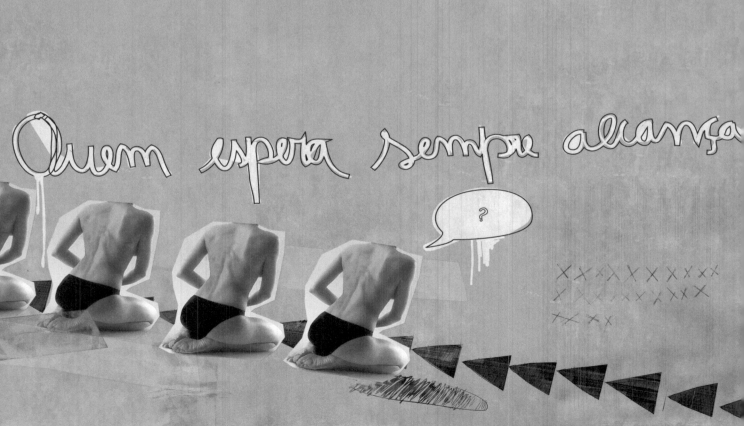

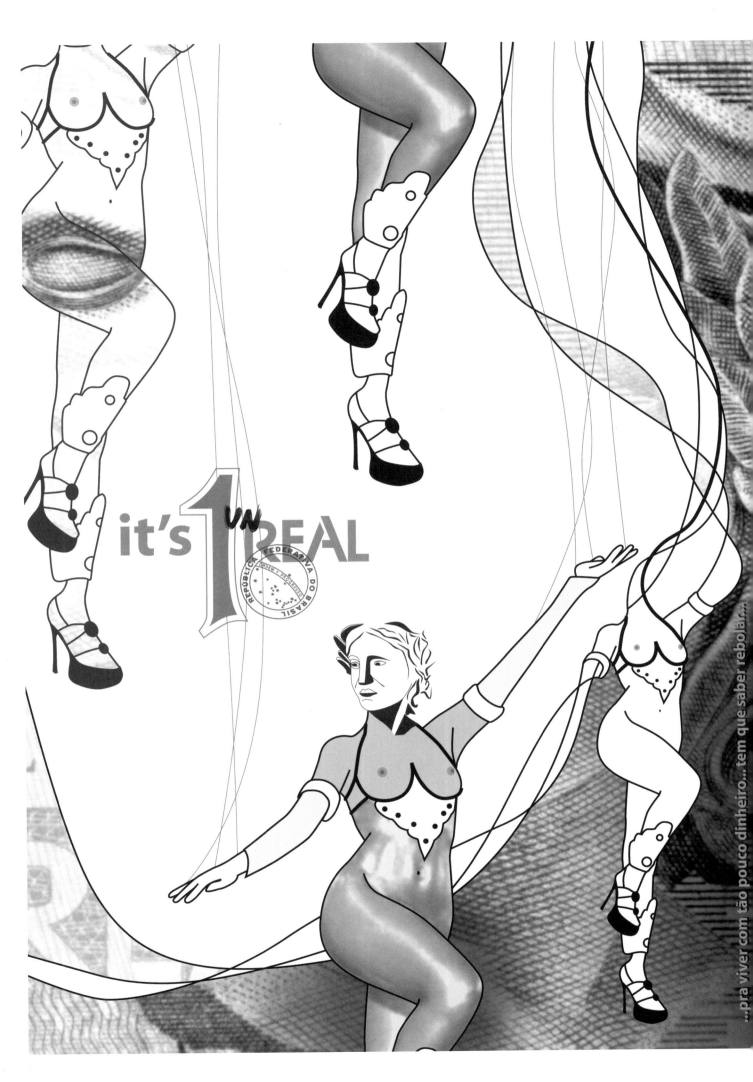

it's 1 unREAL

...pra viver com tão pouco dinheiro...tem que saber rebolar...

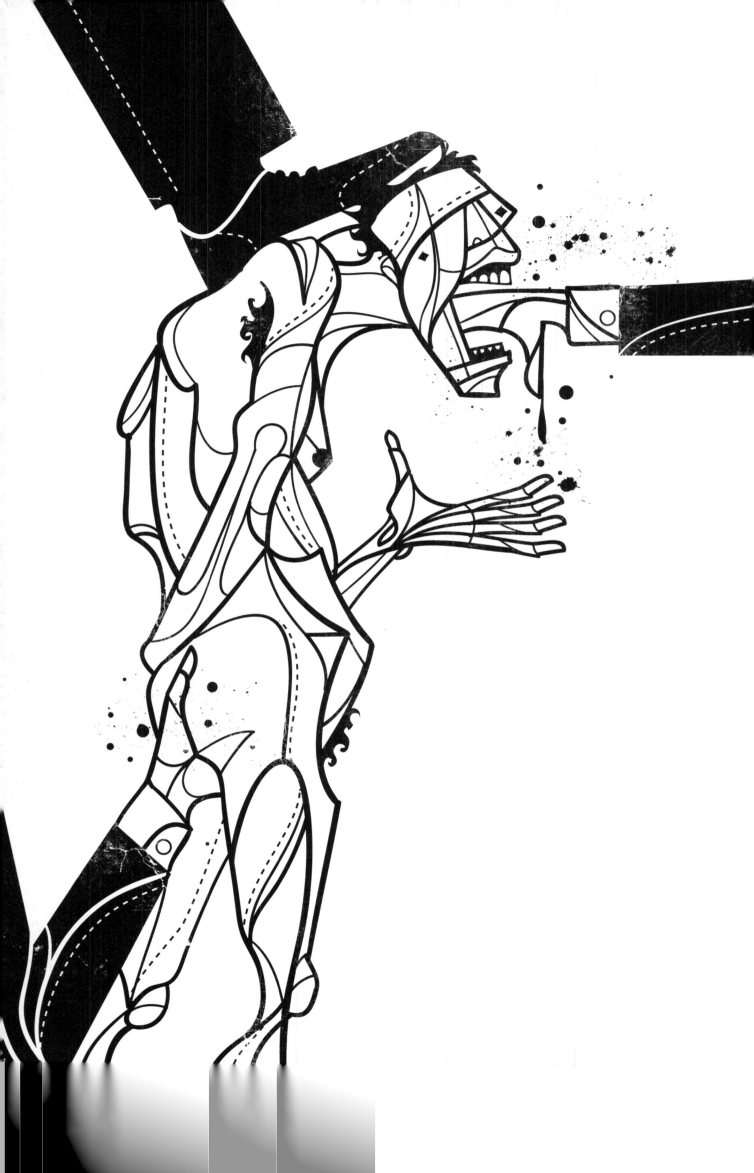

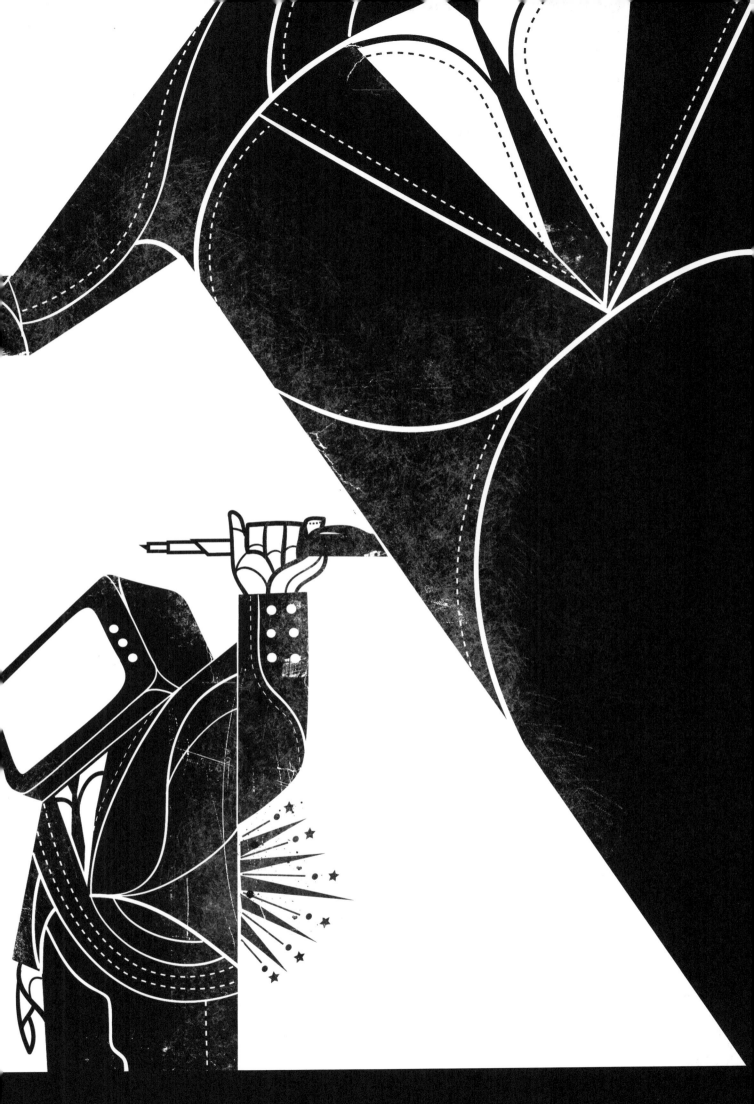

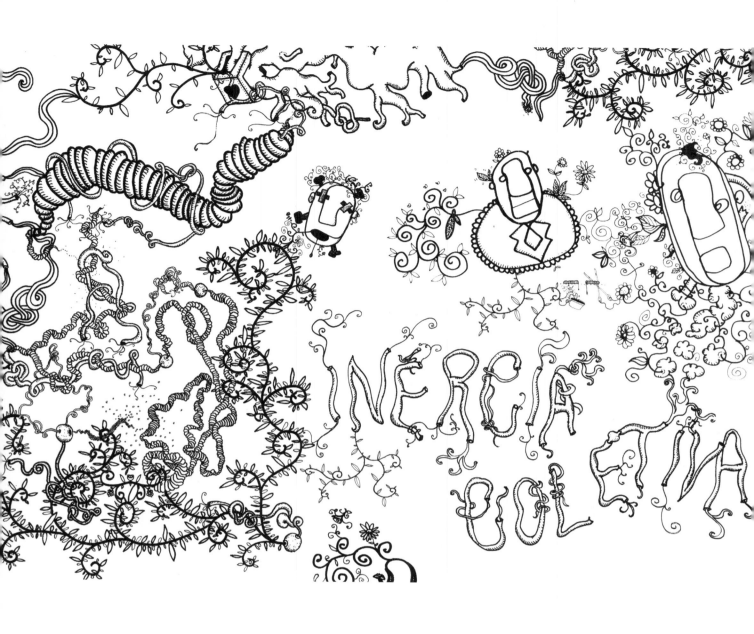

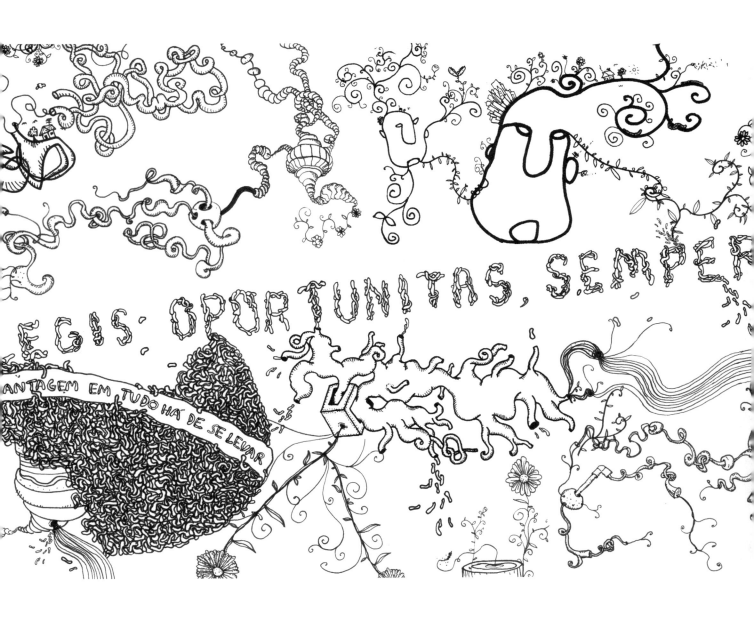

EGIS, OPORTUNITAS, SEMPER

ANTAGEM EM TUDO HÁ DE SE LEVAR

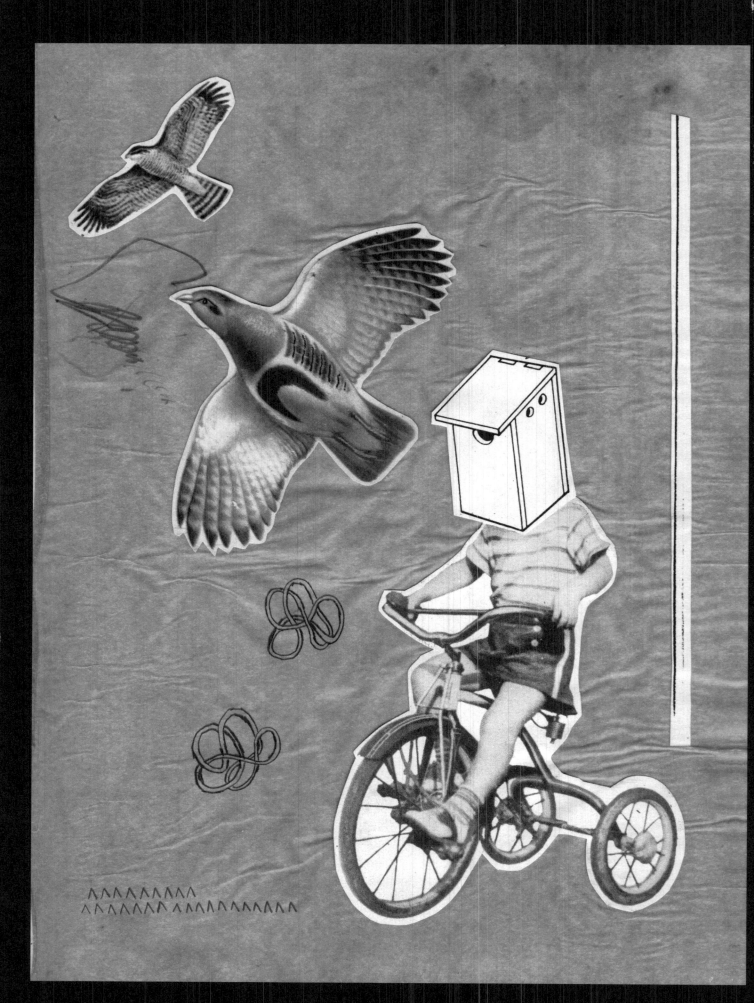

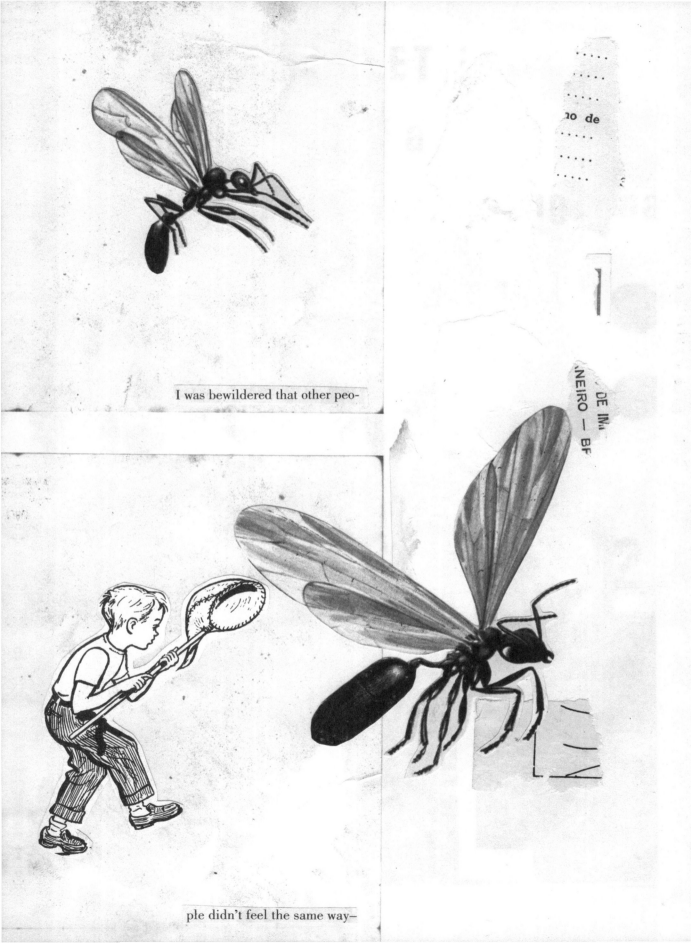

I was bewildered that other peo-

ple didn't feel the same way—

"In spite of the Worker's Party previous reputation for clean and efficient government at the local level, a burgeoning corruption scandal in mid-2005 threatened to destroy Lula's government.

After Brazilian Labour Party (PTB) leader Roberto Jefferson was implicated in a bribery case, he accused the Worker's Party in June of paying members of congress illegal monthly stipends to vote for government-backed legislation. In August, campaign manager Duda Mendonça admitted that he had used illegal money to finance Lula's electoral victory of 2002."

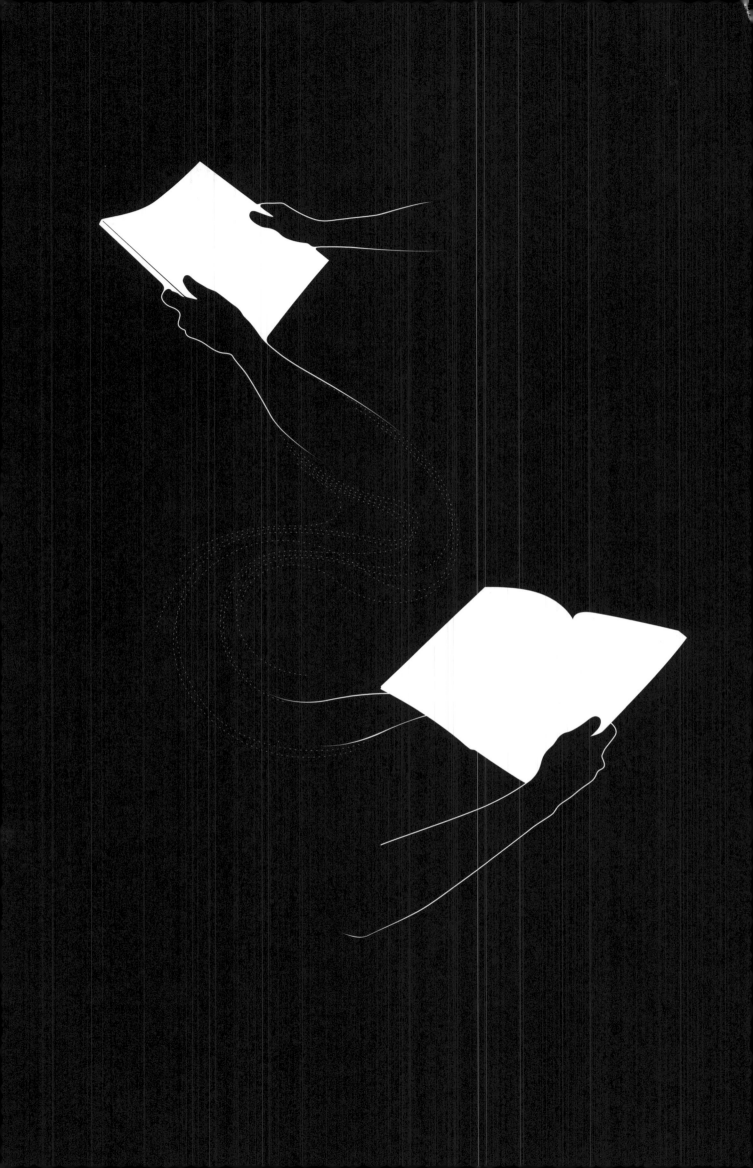

Disorder in Progress

Concept, Layout and Design by
Edited by
Production Management by

Nando Costa
Robert Klanten, Nando Costa
Martin Bretschneider

Published by
Printed by
Made in

Die Gestalten Verlag, Berlin
Offsetdruckerei Grammlich, Pliezhausen
Europe

Thanks from Nando Costa to

My friend Kevin Cimini for the help with the cover.

My wife Linn Olofsdotter for the constant help and support.
My friend Santana Dardot and Sapien for constantly helping
with the Brasil-Inspired projects.
All family and friends for supporting my projects.

Bibliographic information published by

Die Deutsche Bibliothek
Die Deutsche Bibliothek lists this publication in the Deutsche
Nationalbibliografie; detailed bibliographic data is available in
the Internet at http://dnb.ddb.de.

ISBN

3-89955-150-8

For more information about dgv please check out

www.die-gestalten.de

Respect copyright, encourage creativity!

80

. Artist Name: Antônio Junior
. Studio Name: Sapien
. Artwork Title: "Quem Espera Sempre Alcança"
. Place of Birth: Brazil, MG
. Website: www.50percentgray.co.nr

68
79

. Artist Name: Ana Starling
. Artwork Titles: "Egg" | "Street Girl" | "26 Cut Up States"
. Place of Birth: Brazil, MG
. Websites: www.anastarling.com & www.submerso.com

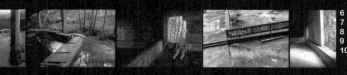
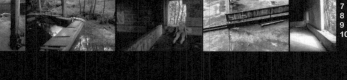
6
7
8
9
10

. Artist Name: Andrezza Valentim
. Artwork Titles: Untitled Series
. Place of Birth: Brazil, SP
. Website: www.andrezza.com

33

. Artist Name: Binho Barreto
. Artwork Title: "Mineração"
. Place of Birth: Brazil, MG
. Website: www.binhobarreto.net

24
25

. Studio Name: Buraco de Bala
. Artwork Titles: "Memória" Series
. Place of Birth: Brazil, DF
. Website: www.buracodebala.com

56
57

. Artist Name: Carlos Bêla
. Studio Name: Golden Shower
. Artwork Titles: "Mentira Global" Series
. Place of Birth: Brazil, SP
. Website: www.goldenshower.gs

27
66
67
81

. Artist Name: Chico Jofilsan
. Artwork Titles: "Glue Huffer Boy" | "Brazilian Culture" |
"Disharmony Fountain" | "Un Real"
. Place of Birth: Brazil, PE
. Website: www.chicoj.com

48
49

. Artist Name: Marcelo Baldin
. Studio Name: Combustion
. Artwork Titles: "Empty Future" | "Burrocracia"
. Place of Birth: Brazil, SP
. Website: www.combustion.ws

28
29

. Artist Name: Daniel Bueno
. Artwork Title: "Focado No Job"
. Place of Birth: Brazil, SP
. Website: www.buenozine.com.br

 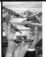 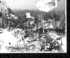

20
21
22
23
61

. Artist Name: Daniel Eskils
. Artwork Titles: "Shadows" Series
. Place of Birth: Sweden
. Website: www.eskils.com

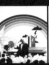

74
75
76
77

. Artists Names: Antônio Pedro & Daniel Neves
. Studio Name: Dimaquina
. Artwork Titles: "Wolves In Suits" | "Welcome To Rio. I'm 13."
. Place of Birth: Brazil, RJ
. Website: www.dimaquina.com

60
63
64
65

. Artists Names: Marcelo Roncatti, Vanessa Queiroz & David Bergamasco
. Studio Name: Estúdio Colletivo de Design
. Artwork Titles: "Official Data" | "We Are Numbers" | "The Typical Brazilian is Born"
. Place of Birth: Brazil, SP
. Website: www.colletivo.com

82
83

. Artist Name: Everson Nazari
. Studio Name: DSlab
. Artwork Title: "Swit Devotion"
. Place of Birth: Brazil, RS
. Website: www.dslab.art.br

84
85

. Artist Name: Gui Borchert
. Artwork Titles: "Inércia Coletiva" | "Legis Oportunitas"
. Place of Birth: Brazil, RJ
. Website: www.guiborchert.com

34
35

. Artist Name: Jovan Almeida
. Artwork Titles: Untitled Series
. Place of Birth: Brazil, RJ
. Website: www.yolksyogurt.com

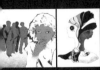

14
15
26

. Artist Name: Linn Olofsdotter
. Studio Name: Lard & Joy
. Artwork Titles: "Baby Love" | "Poor Mother"
. Place of Birth: Sweden
. Websites: www.olofsdotter.com & www.lardandjoy.com

18
19
86
87

. Artist Name: Eduardo Recife
. Studio Name: Misprintedtype
. Artwork Titles: "Violence" | "All For The Money"
. Place of Birth: Brazil, MG
. Website: www.misprintedtype.com

50
51
52
53

. Artist Name: Muti Randolph
. Artwork Titles: Untitled Series
. Place of Birth: Brazil, RJ
. Website: www.muti.cx

30
31
32

. Artist Name: Nando Costa
. Studio Name: Lard & Joy
. Artwork Titles: "Together in Poverty" | "By a Thread"
. Place of Birth: Brazil, RJ
. Websites: www.nandocosta.com, www.brasilinspired.com &
 www.lardandjoy.com

44
45

. Artist Name: Marcilon Almeida
. Studio Name: Nitrocorpz
. Artwork Titles: "The Funny Mr. José!" Series
. Place of Birth: Brazil, GO
. Websites: www.nitrocorpz.com & www.neuralbrand.org

58
59

. Artist Name: Paulo Caetano
. Studio Name: dascinzasdesign
. Artwork Titles: "Seca" | "Violencia"
. Place of Birth: Brazil, RJ
. Website: www.dascinzasdesign.com

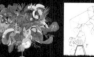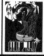

16
17
54
55
69
78

. Artist Name: Raquel Falkenbach
. Artwork Titles: "Calorzinho" | "Descaso" | "O Inimigo" |
 "Podre" | "Turismo"
. Place of Birth: Brazil, RJ
. Website: www.raquelfalkenbach.com

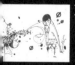

70
71

. Artist Name: Rubens LP
. Artwork Title: Untitled
. Place of Birth: Brazil, RJ
. Website: www.fluxuscentral.com

62
72
73

. Artists Names: Gustavo Timponi & Santana Dardot
. Studio Name: Sapien
. Artwork Titles: "Quem Espera Sempre Alcança" Series & The
 Place Where I Live Is A Virus Inside Me"
. Place of Birth: Brazil, MG
. Website: www.sapien.com.br

43

. Artist Name: Stephan Doitschinoff
. Artwork Title: "Atque Non"
. Place of Birth: Brazil, SP
. Website: www.stephandoit.com.br

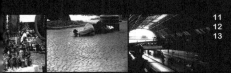

11
12
13

. Artist Name: Sung Hean Baik
. Studio Name: Binatural
. Artwork Titles: "Museu Padre Anchieta" | "Estação da Luz" |
 "Praça Benedito Calisto" | "Praça da República"
. Place of Birth: Brazil, SP
. Website: www.binatural.com.br

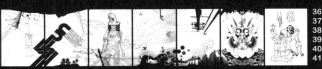

36
37
38
39
40
41

. Artist Name: William Morrisey
. Studio Name: wmwmwm
. Artwork Titles: "I love Brazil, but I don't love..." Series |
 "Street Kids"
. Place of Birth: USA
. Website: www.wmwmwm.com

42

. Artist Name: Yomar Augusto
. Studio Name: vo6
. Artwork Title: "Statue of Souls"
. Place of Birth: Brazil, DF
. Website: www.yvo6.com.br

46
47

. Artists Names: Gabriel Bá & Fábio Moon
. Studio Name: 10 Pãezinhos
. Artwork Title: Untitled
. Place of Birth: Brazil, SP
. Website: www.10paezinhos.com.br

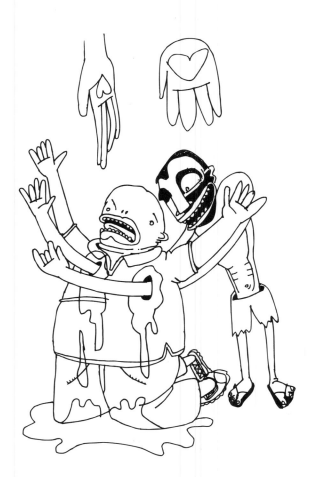